IMAGES
of America

PENSACOLA BAY
A MILITARY HISTORY

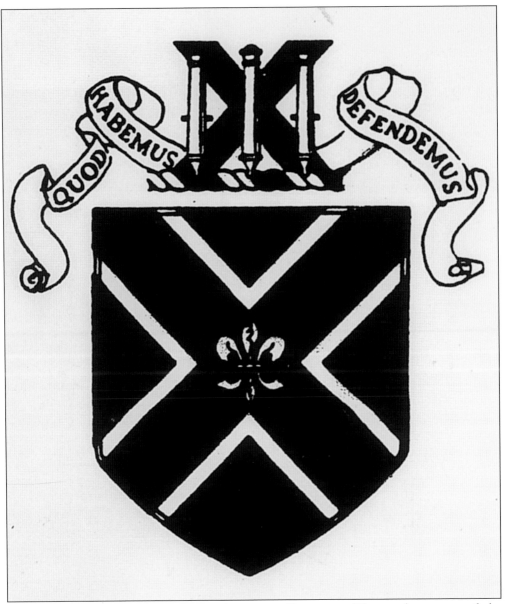

THE INSIGNIA OF THE 13TH COAST ARTILLERY REGIMENT. The southern cross of the Confederacy was placed on the shield because the regiment was formed in the South. In the place of honor, the fleur-de-lis symbolizes the regiment's service in France during World War I. The Roman numeral XIII with artillery pieces on a ship's rope represents the 13th Coast Artillery. The motto, Quod Habemus Defendemus, means "what we hold we will defend." The regiment guarded the southern coast from Charleston, South Carolina, to Galveston, Texas, with detachments in the Panama Canal Zone. The 13th Coast Artillery Regiment specialized in the use of submarine mines, heavy artillery, searchlights, and the tactics of harbor defense. Locally headquartered at Fort Barrancas, the 13th manned the batteries of the sub-posts of the Fort Pickens Reservation and the Fort McRee Reservation. The batteries of the sub-posts were constructed between 1894 and 1942. The coast artillery operated boats for planting mines, towing targets, and ferrying troops to and from Fort Barrancas, Fort Pickens, and Fort McRee.

IMAGES
of America

PENSACOLA BAY
A MILITARY HISTORY

Dale Manuel

ARCADIA
PUBLISHING

Published by Arcadia Publishing
Charleston, South Carolina

Printed in the United States of America

Library of Congress Catalog Card Number: 2003112907

For all general information contact Arcadia Publishing at:
Telephone 843-853-2070
Fax 843-853-0044
E-mail sales@arcadiapublishing.com
For customer service and orders:
Toll-Free 1-888-313-2665

Visit us on the Internet at www.arcadiapublishing.com

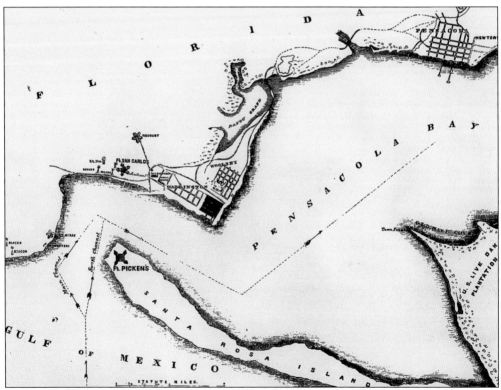

A Civil War Map of the Various Installations on Pensacola Bay. On the western end of Santa Rosa Island is Fort Pickens. Across the pass from Fort Pickens is Fort McRee with its water battery. On the mainland and aligned with the Pass is Fort Barrancas (Fort San Carlos). Behind Fort Barrancas is the Advanced Redoubt. The Navy Yard is bordered by the town of Warrington on the west and the town of Woolsey to the north.

CONTENTS

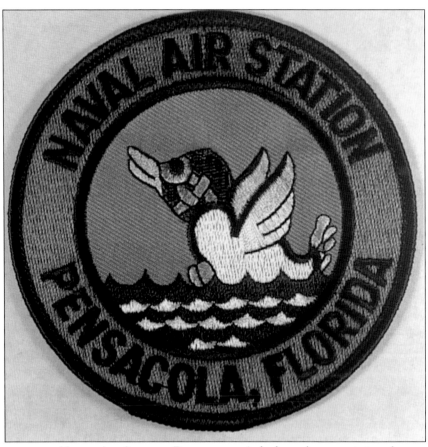

INSIGNIA OF THE NAVAL AIR STATION PENSACOLA. A duck on the water is in reference to the Navy's early use of seaplanes to train aviators.

ACKNOWLEDGMENTS

Many individuals and organizations made this book possible by sharing their images, materials, time, and assistance. Patrick Nichols, in the Public Affairs Office at the Naval Air Station Pensacola, gave me the red carpet tour of the Old Navy Yard site and the Naval Air Station Pensacola. David Ogden, author of several histories on the bay, was a great help with the Gulf Islands National Seashore and National Park Service's photograph collection. Dan Scott (archivist) and Carolyn Prime (curator) at the Pensacola Historical Society helped me find material and photographs in the society's vast collections. Leslie Sheffield at the Florida State Archives (Photographic Collection) was so knowledgeable and helpful. Lt. Michael Blankenship and Chief Victor Brabble in the Blue Angels' Public Affairs Office sent media material. Hill Goodspeed, with the National Museum of Naval Aviation, was very helpful with technical information. Bolling W. Smith (editor of the *Coast Defense Journal*) checked for technical accuracy. Mark A. Berhow (publisher, Coast Defense Study Group) provided technical advice. Last, but not least, the ladies on the fifth floor of the National Archives Cartographic Branch at College Park, Maryland, worked tirelessly for me.

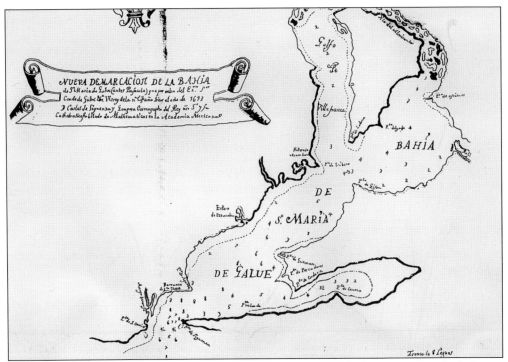

SPANISH MAP OF PENSACOLA BAY, DATED 1693. The bay is called Santa Maria de Galve on the map drawn by Carlos de Siguenza y Gongora, while he was on an expedition headed by Adm. Andres de Pez.

One

COLONIAL

FORTIFICATIONS

Because Spain considered the Gulf of Mexico a Spanish sea, in November 1698, Adm. Andres de Arriola landed at the Barrancas and began the first settlement and fort to hold the vast territory of La Florida against other European incursions. The fort was first called Presidio Santa Maria de Galve and later Fort San Carlos de Austria. Although the first permanent settlement on the bay was poorly manned and supplied, it managed to survive under almost constant attacks by Native Americans.

The French burned the fort in1719 and French and Spanish had exchanged possession of the bay four times by 1722. In 1723, the Spanish rebuilt the settlement on Santa Rosa Island and built a fort they called Presidio Isla de Santa Rosa. After a hurricane destroyed the settlement in 1752, the main Spanish settlement was moved to the present site of Pensacola around a small fort called San Miguel.

In 1763, after the French and Indian War, Florida was ceded to the British. In 1763, the British built the Royal Navy Redoubt on the Barrancas. Between 1771 and 1781, the British built the Fort at Pensacola, Fort George, Queen's Redoubt, and the Prince of Wales Redoubt.

In 1781, the governor of Spanish Louisiana, Bernardo de Galvez, besieged Pensacola. Most of the siege took place on Gage Hill and the British fought well until a direct hit on the magazine of the Queen's Redoubt caused their surrender on May 9, 1781. The Spanish then took possession of the bay and all the British forts. In 1797, the Spanish built Fort San Carlos de Barrancas on the site of the Royal Navy Redoubt and below they built the semi-circular Battery San Antonio.

During the War of 1812, the United States suspected that the Spanish were giving aid to the unfriendly Native Americans and considered the entrance of the British fleet into Pensacola Bay a hostile act. On November 7, 1814, Gen.Andrew Jackson arrived at Pensacola and after a brief skirmish the surrender negotiations began. The drawn-out negotiations enabled the British troops to withdraw from the town, blow up Fort San Carlos de Barrancas, spike the guns of Battery San Antonio, destroy the battery at Point Siguenza, and leave the bay. Jackson soon returned Pensacola to the Spanish and they rebuilt Fort San Carlos de Barrancas.

In May 1818, General Jackson returned to Pensacola believing the Spanish were encouraging Native American attacks in American territory. The Americans, who occupied Pensacola, attacked the Spanish garrison at Fort San Carlos de Barrancas. After a brief fight the Spanish surrendered the fort. After 10 months the United States returned Pensacola to Spain.

In 1821, Spain ceded Florida to the United States. On July 17, 1821, Andrew Jackson raised the American flag at Pensacola, ending the colonial period in Florida.

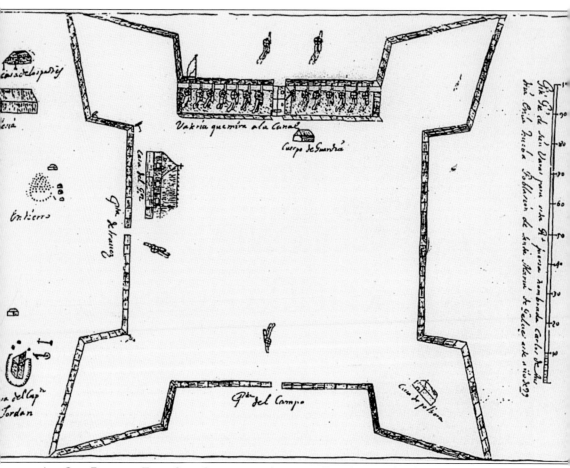

AN OLD PLAN OF FORT SAN CARLOS DE AUSTRIA. Fort San Carlos de Austria, also known as Presidio Santa Maria de Galve, was built by the Spanish on the barranca, or bluff, of the bay in 1698.

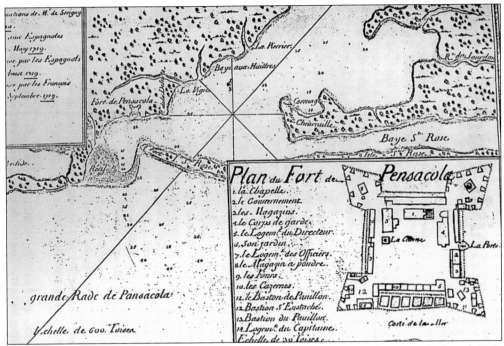

A FRENCH MAP, DATED 1719, OF FORT SAN CARLOS DE AUSTRIA. Between 1719 and 1722, the Spanish and French fought many times for control of Pensacola Bay. The French would destroy the fort in 1719. Another fort is shown at the western end of Santa Rosa Island.

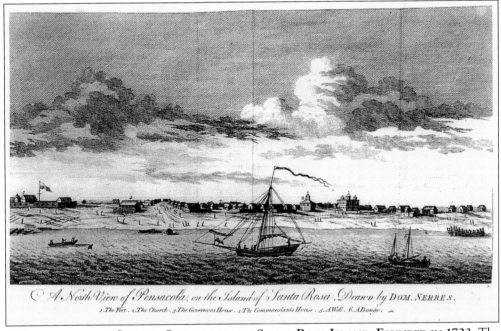

A DRAWING OF THE SPANISH SETTLEMENT ON SANTA ROSA ISLAND, FOUNDED IN 1723. The fort was known as Presidio Isla de Santa Rosa. After a hurricane destroyed the settlement in 1752, the survivors moved the settlement to the present site of Pensacola.

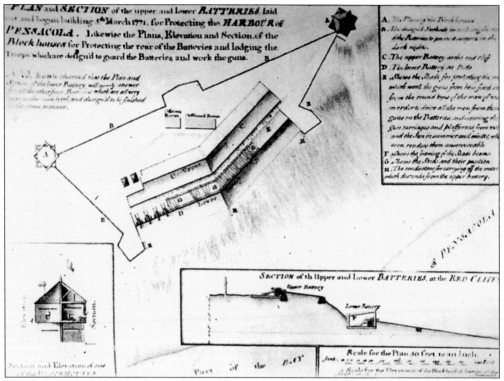

A PLAN OF THE BRITISH NAVAL REDOUBT. The British Naval Redoubt was constructed on the Barrancas in 1763. The British called the Barrancas "Red Cliffs." The redoubt had an upper and lower battery with a stockade and two blockhouses to guard the land side.

BRITISH SHIPS IN THE HARBOR OF BRITISH COLONIAL PENSACOLA. In 1763, Florida was ceded to the British and Pensacola became the capital of West Florida.

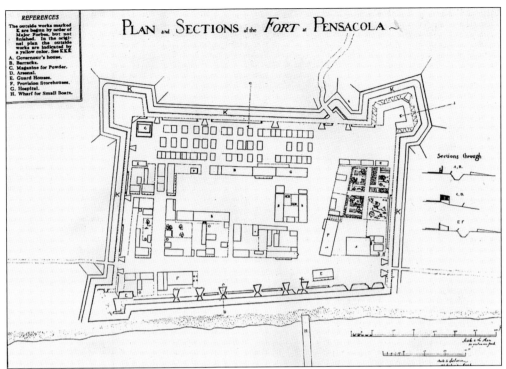

A PLAN OF THE 1780S BRITISH FORT AT PENSACOLA. This stockade fort was constructed in the city of Pensacola to protect its inhabitants.

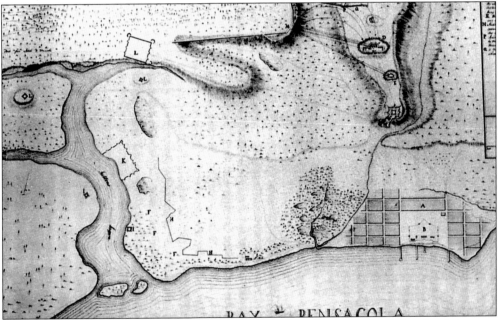

MAP OF THE 1781 SPANISH SIEGE OF PENSACOLA. Gov. Bernardo de Galvez landed troops at Sutton's Lagoon and marched inland to Galvez Spring, where batteries and siege lines were drawn for an assault on the redoubts and Fort George. The map shows the Fort of Pensacola, Fort George, and the Prince of Wales and Queen's Redoubt.

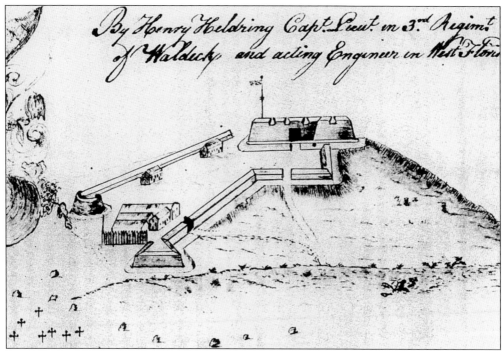

A Drawing of British Fort George on Gage Hill. Constructed some 1,200 yards north of Pensacola's old Spanish plaza to guard the heights that commanded the town, the main fort was a four-pointed star with descending hornwork. At the bottom of the hornwork were two blockhouses to guard the Mobile Road. The British built the Queen's Redoubt and the Prince of Wales Redoubt to guard the upper heights above Fort George.

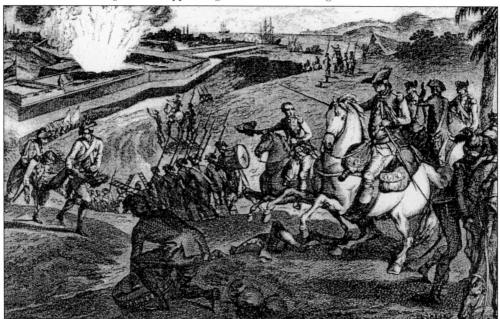

A Romantic View of Galvez's Siege of the Queen's Redoubt. When the magazine exploded, many of the British defenders were killed and the British were forced to surrender.

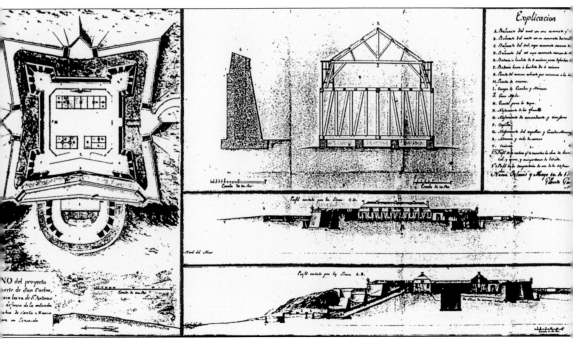

A PLAN OF THE OLD SPANISH FORT SAN CARLOS DE BARRANCAS WITH THE SEMI-CIRCULAR WATER BATTERY SAN ANTONIO BELOW IT. Work on the fort and battery started in 1797; it was the principal fortification during the rest of the colonial period. The fort was a classic bastioned square with the semi-circular Battery San Antonio that served as the water battery.

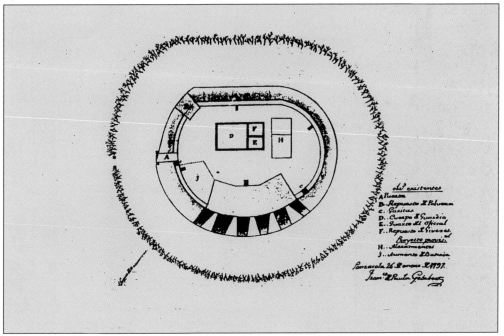

A PLAN OF THE BATTERY ON POINT SIGÜENZA AT THE WESTERN END OF SANTA ROSA ISLAND. Francisco P. Gelabert drew the plan in 1797 with a gun platform and embrasures for five guns. The retreating British destroyed this battery during the War of 1812.

15

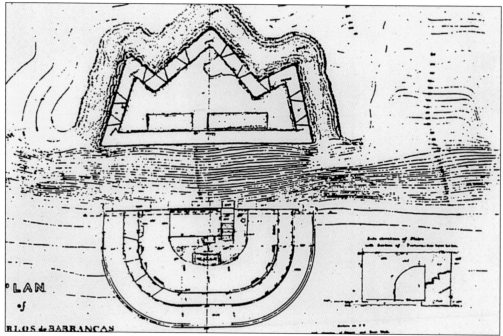

A PLAN OF THE FORT SAN CARLOS DE BARRANCAS WITH THE OLD SPANISH BATTERY SAN ANTONIO BELOW IT. This was the fort captured by American forces in 1818. In August of that year, Capt. James Gadsden surveyed the defenses of Pensacola and commented on the strategic importance of a fort on the barrancas and on the western tip of Santa Rosa Island. Pensacola and the fort would soon be returned to Spain.

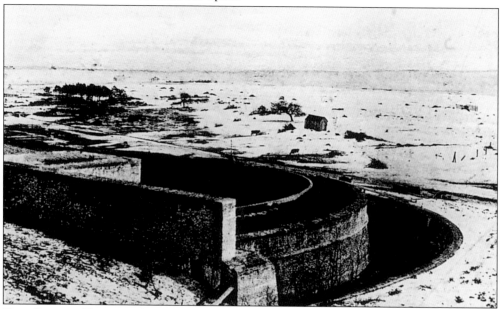

OLD SPANISH BATTERY SAN ANTONIO IN 1907. In 1840, the Old Spanish Battery San Antonio was refurbished to serve as the water battery for the American Third System Fort Barrancas. The old brick and stucco battery is the only colonial fortification to survive to the present day.

16

Two

THE OLD NAVY YARD

In October 1825, Tarter Point was selected as the site for the Navy Yard. The yard was to base the Gulf Squadron,whose primary mission was to suppress the slave trade and piracy in the Gulf of Mexico and the Caribbean. The early Navy Yard would consist of a walled yard of 80 acres, a walled Naval Hospital, and a 1,300-acre live oak plantation. Building the Navy Yard was no easy task. There was a shortage of materials, supplies, and skilled labor. Yellow fever epidemics also slowed progress on the Yard. To protect the Navy Yard, between 1829 and 1859, the Army Corps of Engineers would build four forts: Fort Pickens, Fort McRee, Fort Barrancas, and the Advanced Redoubt.

In 1861, Confederates seized the Navy Yard as well as all the mainland forts of Barrancas, McRee, and the Advanced Redoubt. Fort Pickens, across the bay, stayed in Union control. The Navy Yard was heavily damaged during the bombardments of November 22, 1861 and January 1, 1862. In the spring of 1862, with pressing needs elsewhere and because Union troops occupied the strong position of Fort Pickens, the Confederates abandoned Pensacola. The retreating Confederates razed most of the buildings of the Navy Yard.

After Union troops reoccupied the Navy Yard, the base was repaired and became a blockade station. Many of the current structures were constructed during and after the Civil War. By 1911, the Yard had fallen into disuse and was decommissioned. The Yard did not stay on a caretaker status for long. In 1914, the Old Navy Yard would serve as the nucleus of a new mission: Naval Air Station Pensacola.

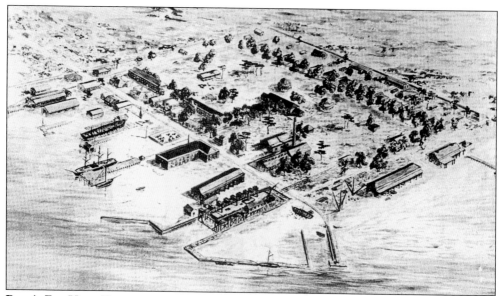

BIRD'S EYE VIEW DRAWING OF THE PENSACOLA NAVY YARD, 1858. A brick wall surrounded the original 80 acres. A central wharf leads to Central Avenue. Of the two octagonal buildings near the center of the yard, one served as an office and the other as a chapel. Near the bottom of the drawing is the basin and to the east of it is the wet slip.

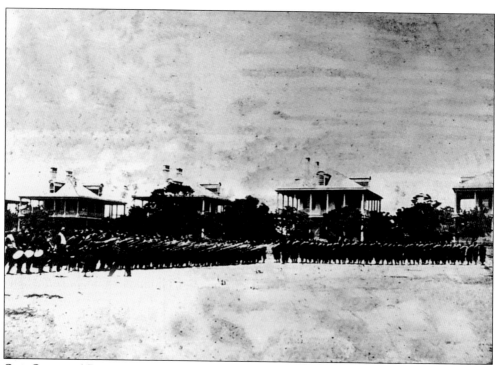

OLD OFFICERS' ROW AT THE OLD NAVY YARD IN 1861. The 1st Louisiana Zouave Battalion demonstrates in front of quarters at the Navy Yard. The entire row of buildings was burned to the ground by the retreating Confederates in 1862.

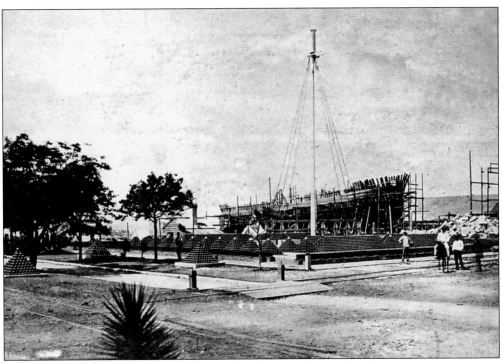

THE STEAMER *FULTON* ON STOCKS IN THE OLD NAVY YARD IN 1861.

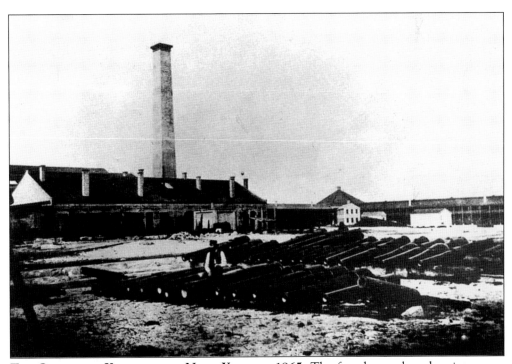

THE ORDNANCE YARD AT THE NAVY YARD IN 1865. The foundry stack and maintenance buildings are in the background.

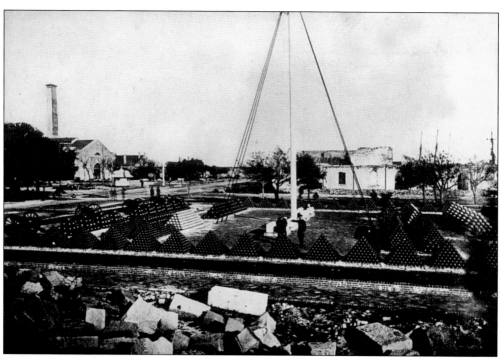

STACKED CANNONBALLS AND THE FLAG POLE AT THE NAVY YARD IN 1865.

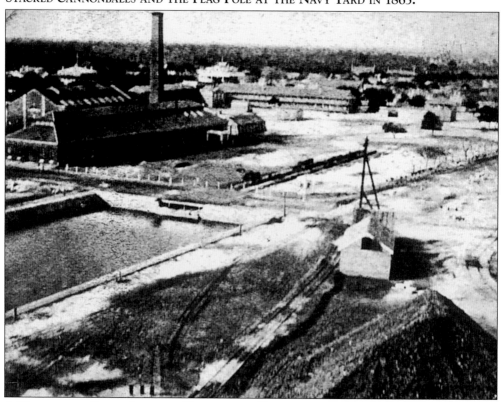

A VIEW OF THE BASIN, LOOKING TOWARD THE FOUNDRY.

A View of Central Avenue at the Navy Yard. Looking towards the Commandant's Quarters, one of the barracks buildings is on the left while the maintenance area is to the right.

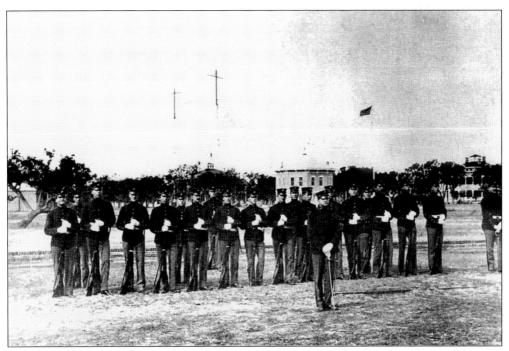

The Inspection of Marines at the Navy Yard in 1907. The old octagonal building and commandant's quarters can be seen in the background.

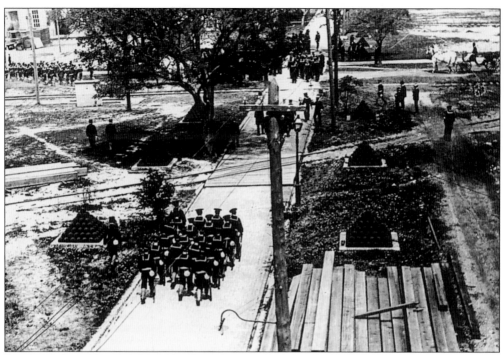

Sailors March Down Central Avenue to Their Barracks.

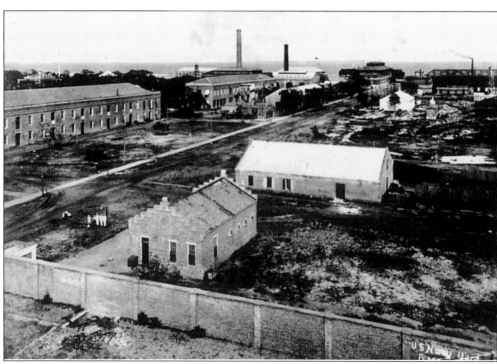

A View of the Navy Yard Toward the East in 1907. Notice the brick wall that separated the yard from the towns of Warrington and Woolsey.

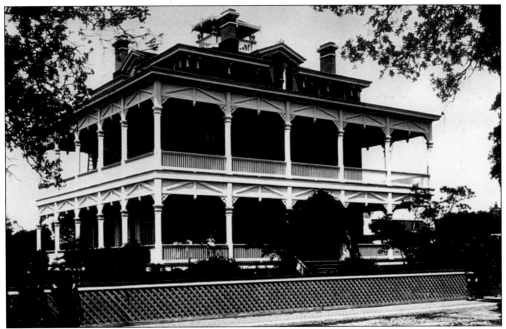

THE COMMANDANT'S HOUSE AT THE NAVY YARD. Built in 1874, Quarters A, also known as the Commandant's House, is said to be haunted. During a yellow fever epidemic, the residing commandant feared contracting the disease and decided to live in the cupola above the third floor. A popular belief at the time was that the miasma that they thought caused the disease could not float above eight feet. The Commandant's meals were served in a basket raised by a rope, and rum was always included as a "tonic" against the fever. One day the rum was forgotten and the commandant died shortly thereafter. Mysterious tapping and the feeling of being followed throughout the house, support the claim that the commandant's ghost, as well as the ghost of a lovely lady, still live in the house.

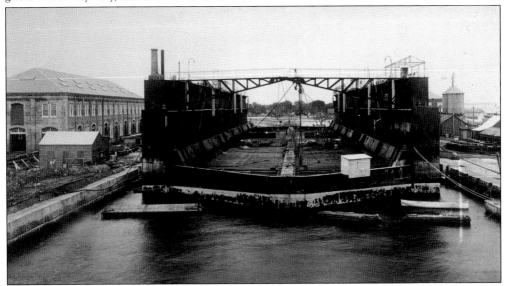

A FLOATING DRY DOCK AT THE NAVY YARD IN 1903. The floating dry dock was used to repair and build vessels. To the left of the basin is the main maintenance building.

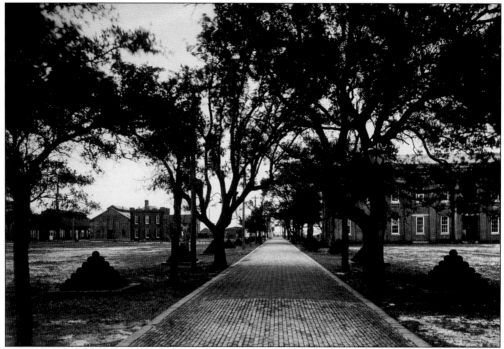

A VIEW OF CENTRAL AVENUE. Looking toward the central wharf, the maintenance area is on the left while one of the barracks is on the right.

THE OLD HOSPITAL AT THE NAVY YARD. The 15-acre hospital compound was completed in 1834. The 12-foot wall around the first Naval Hospital was built in 1835 and provided security for the hospital grounds. Legend has it that at the time people believed the height of the wall would prevent the miasma thought to cause yellow fever and malaria from floating over.

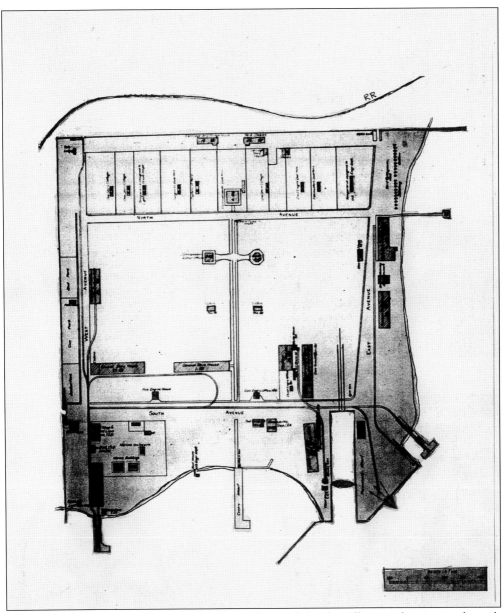

AN 1898 PLAN OF THE PENSACOLA NAVY YARD. A brick wall is to the west and north enclosing the 80 acres of the original yard. The central wharf leads to Central Avenue. At the end of Central Avenue is the Commandant's House and to the right of the avenue is the octagonal building. Barracks are to the left of Central Avenue, and the maintenance area is to the right. The main gate was in the west wall and aligned with South Avenue. The boat basin is to the right of the central wharf and to the right of the basin is the wet slip. Officers' row is along North Avenue.

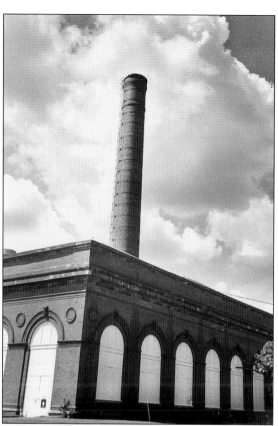

THE OLD FOUNDRY AND SMOKE STACK OF THE OLD YARD. Forging and metal work were done in the foundry to repair and build ships.

OLD OFFICERS' ROW AT THE OLD NAVY YARD. The actual quarters are small. Because of the climate, most of the structure consists of screened-in porches.

Three

BRICK BASTIONS

In 1829, construction began on the first of four Third System brick forts to guard the harbor of Pensacola Bay: Fort Pickens. William H. Chase of the Army Corps of Engineers would supervise the construction of all of the forts. Fort Pickens would be the largest on the Bay. Built on the western end of Santa Rosa Island, the fort was a truncated pentagon with two long casemated two-tiered faces that commanded the entrance to Pensacola Pass.

Designed in 1829 by Gen. Simon Bernard, Fort McRee would begin construction in 1834 on a narrow strip of sand called Foster's Bank. Built across from Fort Pickens, Fort McRee was an unusual shaped bent ellipse. Three tiered faces added firepower to guard the Pass. In 1850, the trapezoidal South Exterior Battery was built 440 yards from Fort McRee to add more fire on the Pass. From the beginning Fort McRee and its exterior battery have fought a losing battle with the sea and have vanished.

Began in 1840, Fort Barrancas was built on the bluff or barranca of the mainland overlooking the Old Spanish Battery San Antonio. The four-sided fort featured two tiers with musket galleries in the first and guns en barbette on the top tier. The semi-circular Battery San Antonio was built by the Spanish in 1794 and was refurbished in the 1840s to serve as the water battery.

A fourth fort was planned because the Navy Yard was thought to be vulnerable from attack by land across the narrow peninsula on which it was built. In 1845, construction on the Advanced Redoubt began 700 yards north of Fort Barrancas to anchor a line of entrenchments. This fort was designed for land defense only.

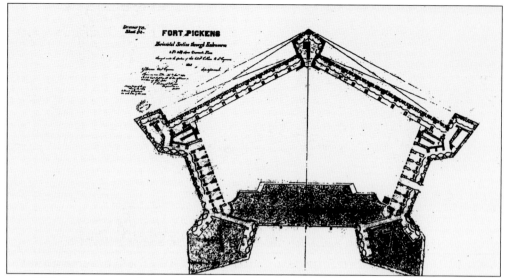

An 1829 Plan of the Large, Truncated Pentagon Fort Pickens. The fort was to be constructed in a commanding position at the western end of Santa Rosa Island to guard the entrance into Pensacola Bay. Joseph Totten is credited with the design of the two channel fronts, while Gen. Simon Bernard is credited with designing the two side flanks and the gorge of the fort. Four brick Third System forts were constructed on the bay: Fort Pickens, Fort McRee, Fort Barrancas, and the Advanced Redoubt. Capt. William Chase supervised the building of each and every one.

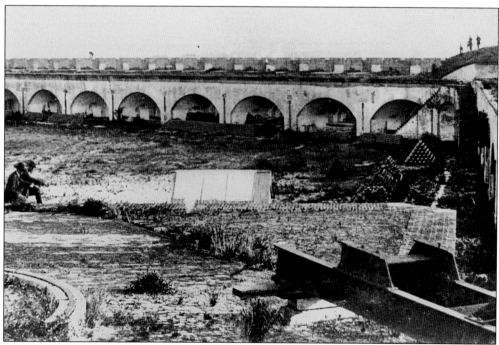

A View of the Parade and Casemated Channel Faces of Fort Pickens. This view is from the top of the northwest bastion looking toward both channel side faces and the center staircase to the tower bastion.

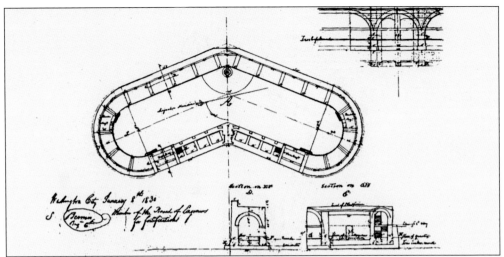

AN 1829 PLAN OF THE BENT, ELLIPTICAL CASTLE FORT McREE. The fort was constructed on Foster's Bank across the mouth of the bay from Fort Pickens. The plan was drawn by Guillaume Tell Poussin and designed by Gen. Simon Bernard. Fort McRee was named in honor of Col. William McRee of the Army Corps of Engineers who built forts in Georgia and Louisiana during the War of 1812. Colonel McRee resigned from the army in 1819 because he resented the appointment of the foreign French engineer, Gen. Simon Bernard. Ironically, it would be Bernard who would design the fort that would bear McRee's name. Of the four forts built on the bay, only Fort McRee has vanished, a victim of the encroaching sea.

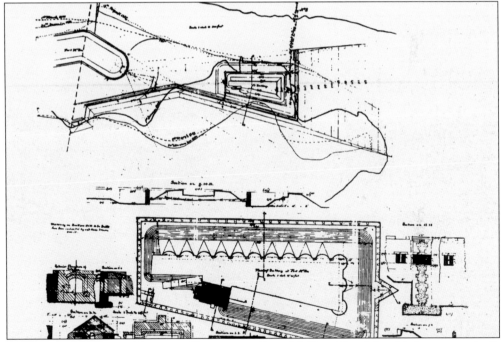

A PLAN OF THE SOUTH EXTERIOR BATTERY OF FORT McREE. The defensible battery was built in 1850, 440 yards from the fort, and featured a surrounding brick Carnot's wall or detached scarp. The wall was pierced with musket loopholes and had only one flanking structure, a small redan on the south side. The battery long ago disappeared into the sea.

29

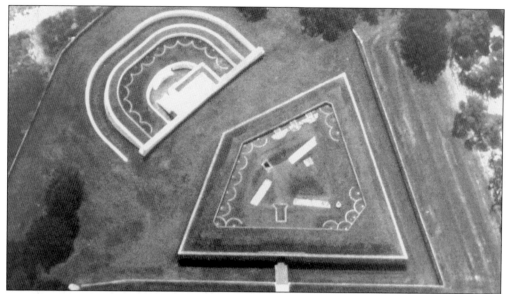

AN AERIAL VIEW OF FORT BARRANCAS AND ITS WATER BATTERY. The shape of the main fort can clearly be seen. The drawbridge spans the dry ditch to the sallyport that leads to the parade. On the parade are ramps that lead to the barbette gun emplacements on the terreplein. At the center of the waterside barbette battery is the entrance to the subterranean tunnel that leads to the lower water battery. Construction of the main works of the fort began in 1840.

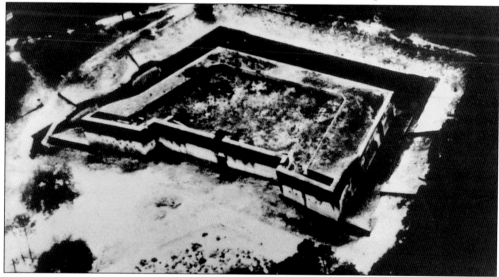

AERIAL VIEW OF THE ADVANCED REDOUBT, BUILT BETWEEN 1845 AND 1859. The redoubt was constructed 700 yards to the rear of Fort Barrancas to anchor a line of entrenchments that guarded the land approach to the Navy Yard. The fort's simple trapezoid design represented a zenith in fortification design. From its simple design four levels of defense could be used against assault. The first level was the barbette guns on the open terreplein of the main work. The second level was the rifles and guns behind the covered way. The third level was the musket loopholes in the musket gallery of the main work that commanded the covered way. The fourth level was the counterfire from loopholes and flank guns in the counterscarp gallery that would have decimated ranks with bullets and canister.

A Portrait of Capt. William H. Chase of the Elite Army Corps of Engineers. Chase spent over 30 years supervising construction of all the forts on Pensacola Bay. Chase was born in Massachusetts in 1798 and graduated from the United States Military Academy in 1815. In the spring of 1861, an aged Colonel Chase took command of Confederate troops in Pensacola and demanded the surrender of Fort Pickens, which the Union held, with a trembling voice and eyes filled with tears. The Union commander of Fort Pickens, Lt. Adam J. Slemmer, refused the surrender. Chase knew the Bay's largest and strongest fort would be extremely hard to capture and would cost a great loss of life.

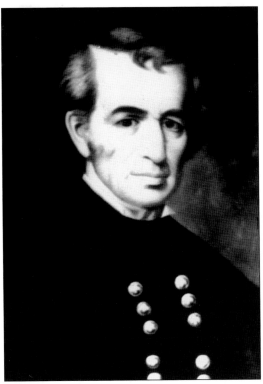

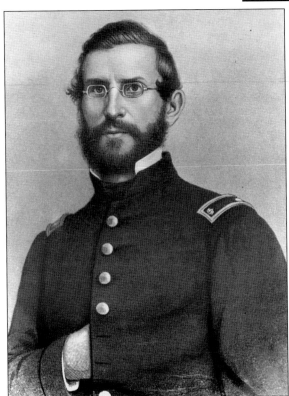

A Drawing of Lt. Adam J. Slemmer. On the night of January 10, 1861, First Lt. Adam J. Slemmer moved his small command of 50 soldiers and 30 sailors from Fort Barrancas to Fort Pickens. Florida and Alabama troops occupied the rest of the installations on the bay. It was Slemmer who refused to surrender Fort Pickens to the fort's builder, William H. Chase, and held out until reinforcements landed in April.

31

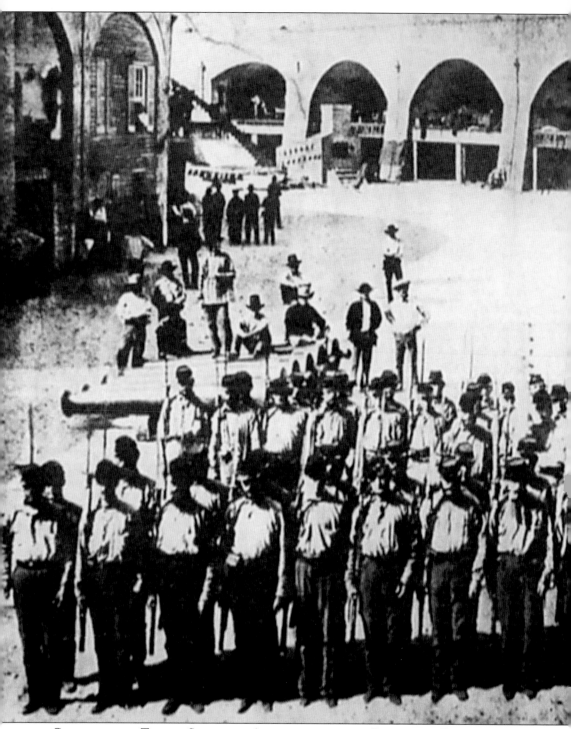

CONFEDERATES TROOPS STAND AT ATTENTION ON THE PARADE OF FORT MCREE. The three-tiered fort featured two tiers of casemated guns under one giant barrel-vaulted arch. Each casemated gun tier held two guns, and the arches were divided by a wooden deck. Above the

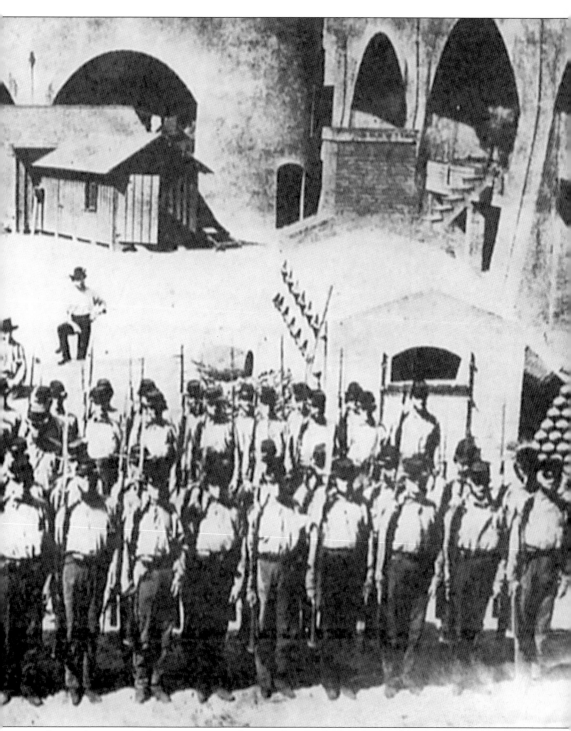

arch was the open barbette gun tier with guns that fired over the brick parapet. A center stair tower, two curved end staircases, and two iron stairs on each end of the gorge reached the second and barbette tiers. A large hotshot furnace was on each side of the two waterfronts.

CONFEDERATE TROOPS STAND AT ATTENTION IN BACK OF FORT McREE. This image of the gorge area shows one of the curved ends, two tiers of embrasures, and the sallyport.

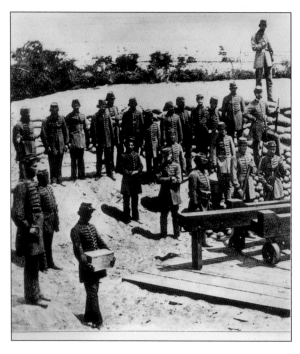

CONFEDERATES MAN THEIR GUN IN ONE OF THE BATTERIES THAT LINED THE BAY.

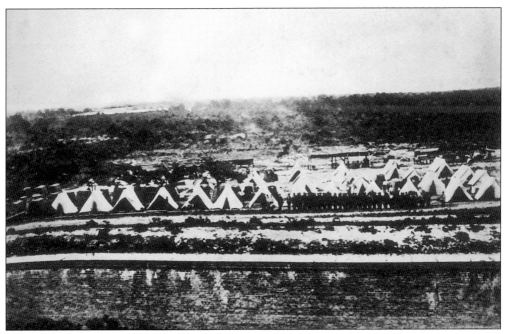

A Confederate Camp Behind Fort Barrancas in 1861.

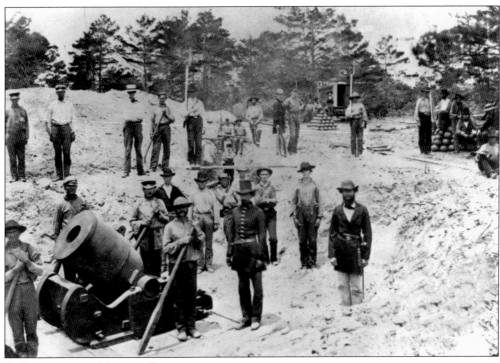

A Confederate Mortar Battery.

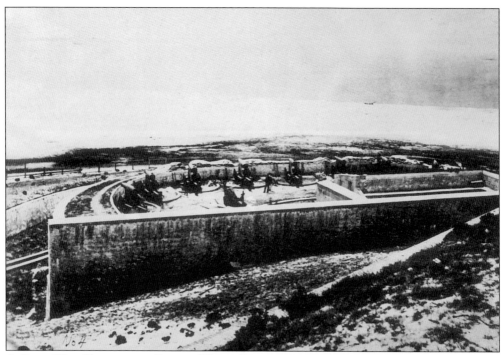

A Civil War View of the Lower Water Battery at Fort Barrancas.

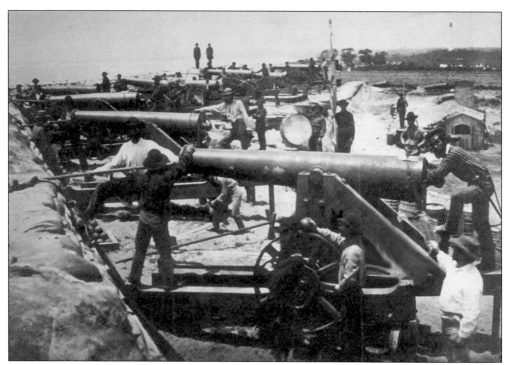

Confederate Gunners Man Their 32-Pounder Guns Mounted on the Terreplein of Fort Barrancas. The hotshot furnace and Pensacola Lighthouse can be seen in the background. The fort's parapets rise to an elevation of 69 feet above the bay.

36

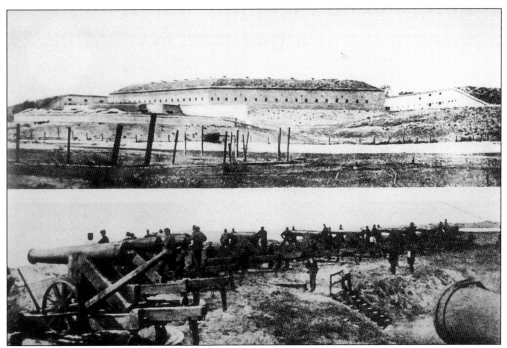

EXTERIOR AND INTERIOR VIEWS OF CIVIL WAR FORT BARRANCAS. The top image is of the main fort and its water battery. The bottom image is the barbette gun battery on the open terreplein of the main fort.

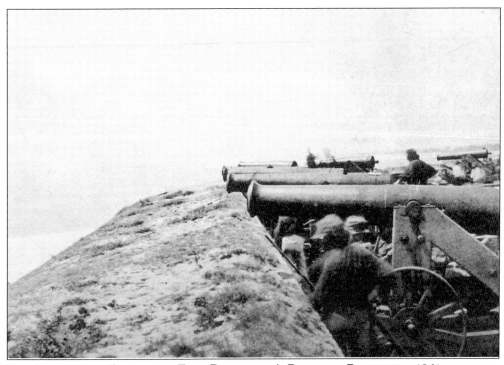

THE GUNS AT THE PARAPET OF FORT BARRANCAS'S BARBETTE BATTERY IN 1861.

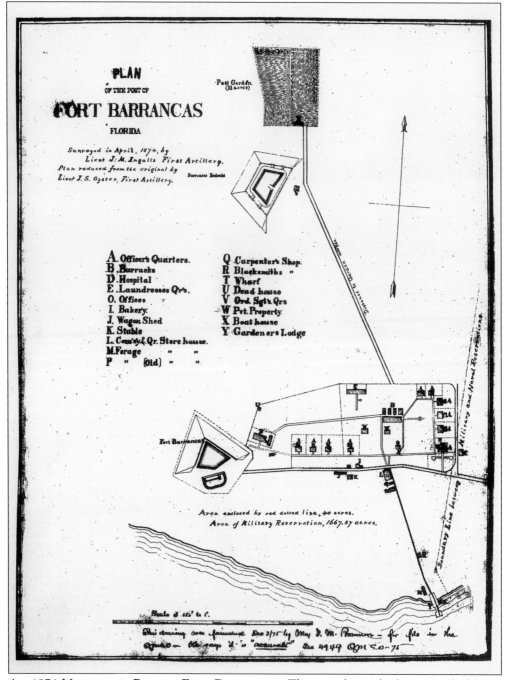

AN 1874 MAP OF THE POST OF FORT BARRANCAS. The map shows the location of Old Fort Barrancas, the Advanced Redoubt, and parade of the post.

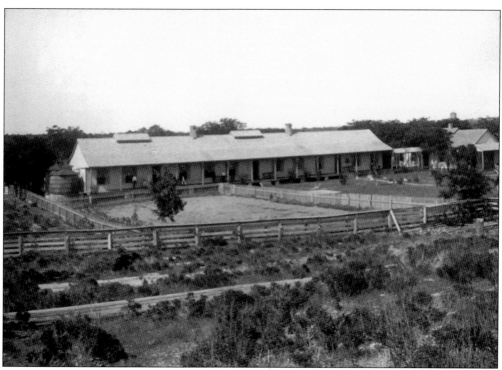

THE OLD POST HOSPITAL AT FORT BARRANCAS. During yellow fever epidemics, the nearby morgue was usually filled to capacity.

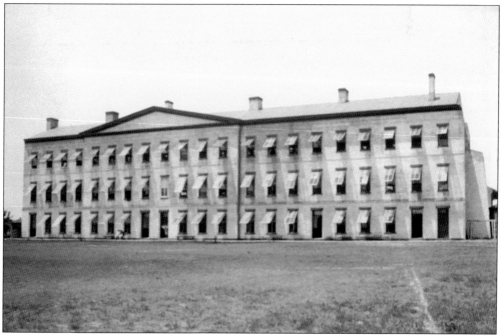

A VIEW OF BARRANCAS BARRACKS. The three-story Barrancas Barracks was constructed in 1847 and could house 400 men. It was the principal enlisted men's barracks until the "White House" was built in the 1930s.

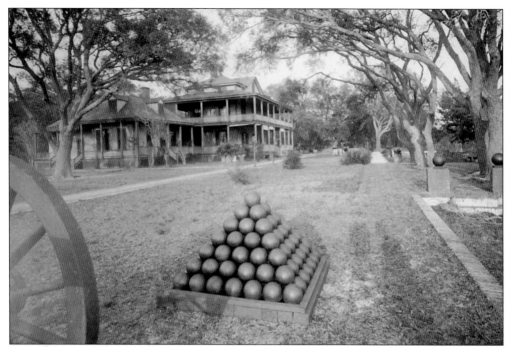

THE COMMANDING OFFICER'S QUARTERS AT FORT BARRANCAS. The neat pyramids of cannonballs were for decoration. Most of the cannonballs and bricks used to build the patio behind "B" barracks were salvaged from the Fort Pickens area. Every man brought back one cannonball or two bricks, or they did not get on the ferry back to Fort Barrancas.

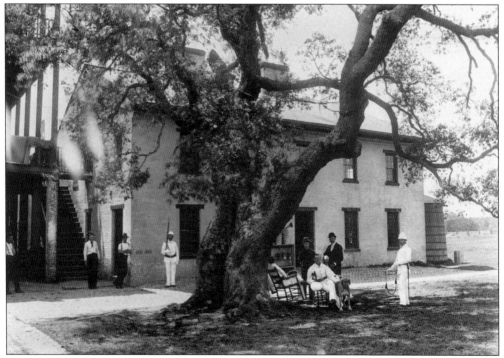

THE GUARDHOUSE AT FORT BARRANCAS. Guards are dressed in white uniforms with helmets.

THE MUSKET GALLERY OF EITHER FORT BARRANCAS OR THE ADVANCED REDOUBT. Men could fire rifles through the loopholes in the scarp of these galleries to protect the ditch and the covered way of the fortification.

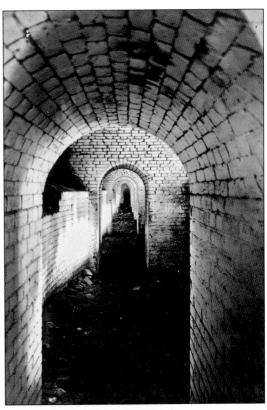

A GATLING GUN AT FORT BARRANCAS IN THE 1880S.

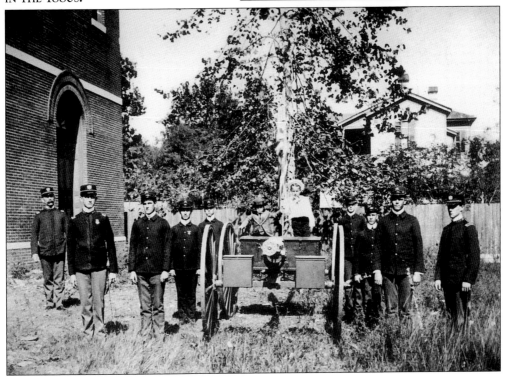

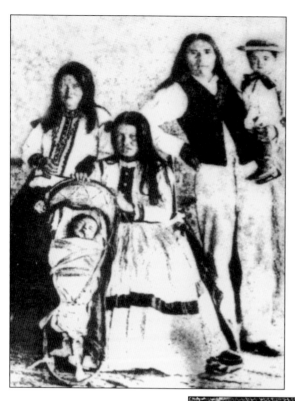

APACHES AT FORT PICKENS. During the Indian detention, Geronimo and other Chiricahua Apaches were held at Fort Pickens. This image is of the family of Perico, a cousin of Geronimo. The infant is Frederick, born on March 30, 1888. He was the only child born in Fort Pickens during this time.

A RARE IMAGE OF THE SALLYPORT OF THE DETERIORATING FORT McREE. The inner arch once held two large, wooden, iron-studded doors. The outer arch in the scarp provided an indentation for an overhanging machicoulis from which projectiles could be dropped or muskets fired down on attackers. The center stair tower on the other side of the parade can be seen through the sallyport. The 130-degree angle of the bent ellipse could form a flanking crossfire in the gorge area to defend the sallyport, the fort's only entrance. Flank 24-pound corronades or howitzers in the two casemated gorge tiers, as well as the gorge barbette guns, guarded this rear area of the fort.

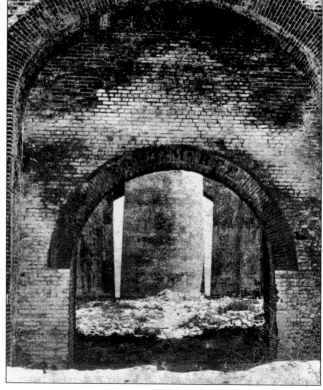

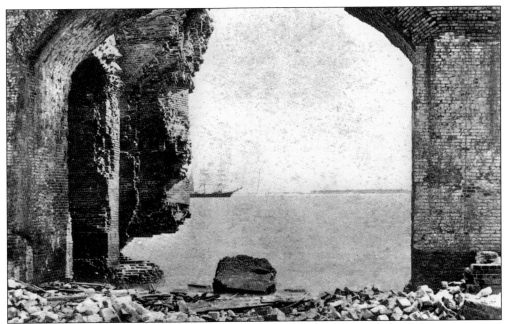

AN ARCH IN THE RUINS OF FORT MCREE THAT WAS ONCE PART OF THE GORGE. Buffs and students of the Third System lament the loss of Fort McRee with its graceful barrel casemate arches that intersected at curved angles with just as graceful barrel vaulted galleries.

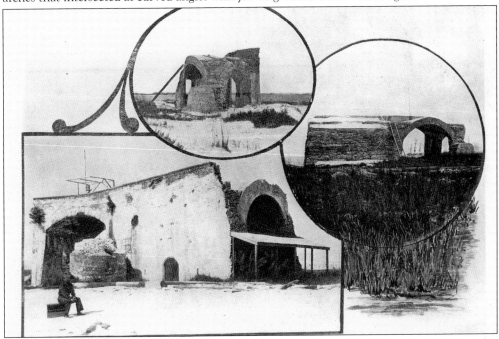

THREE VIEWS OF THE LAST SURVIVING SECTION OF THE NOW VANISHED FORT MCREE. This is an arch in the northwest corner of the gorge. On the right side of these ruins is what remains of one of the storage magazines. The cylinder object is the remains of one of the above ground cisterns that were once under one of the iron stairs. The arches in the gorge were smaller than the water faces and end arches.

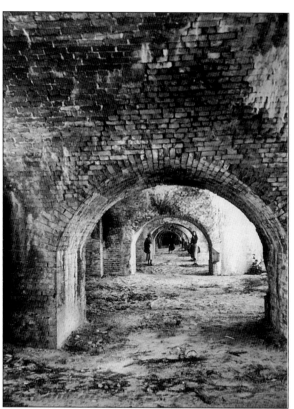

THE ARCHES OF THE CASEMATE GALLERY OF FORT PICKENS. Beneath the floor of the gallery are reversed arches. During construction of Fort Pickens, inverted or reversed arches were added to the foundation to distribute the weight of the structure evenly on the soft, sandy soil. This method reduces great horizontal stress at any one point on the footings.

THE BAKERY OF FORT BARRANCAS. The wooden barrels on the front porch once contained flour. An above-ground cypress cistern was the bakery's water source.

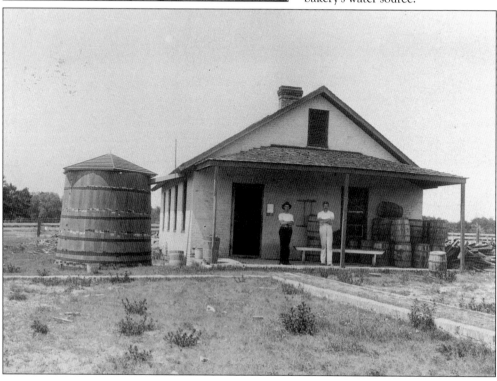

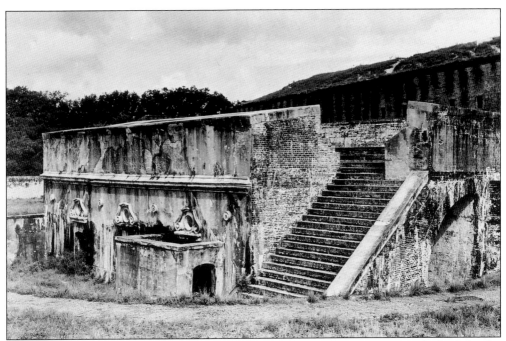

THE OLD REDUIT OF THE WATER BATTERY OF FORT BARRANCAS. Originally built by the Spanish of brick and stucco, the reduit contained storerooms and a powder magazine. A stairway leads up to a musket platform.

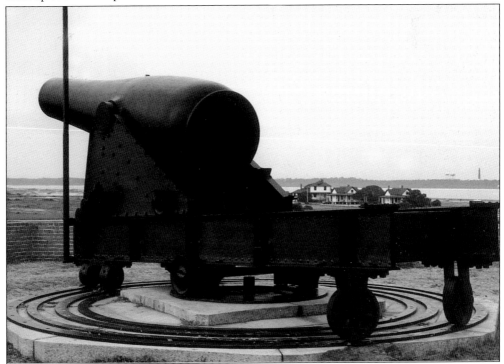

THE 15-INCH RODMAN GUN DISPLAYED ON TOP OF THE CENTER TOWER BASTION AT FORT PICKENS. These guns were first installed atop the tower bastion and end bastions in 1868.

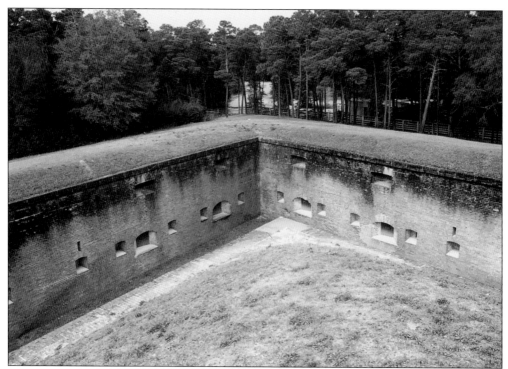

Corner of Fort Barrancas Where the Two-landside Counterscarp Walls Meet. In this corner are four counterfire embrasures and rooms to flank the two dry ditches. The smaller musket loopholes line the counterscarp from end to end. Above the embrasures and loopholes are vents.

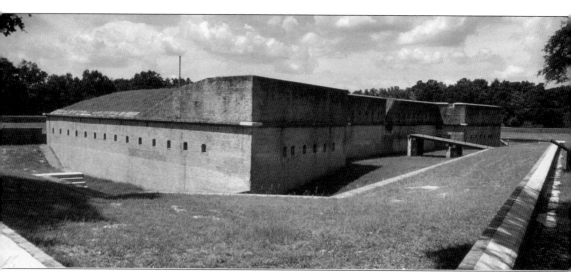

The Gorge Area of the Advanced Redoubt. Guns in the demibastions of the gorge guarded the gorge area. In the center is the drawbridge that leads to the sally port.

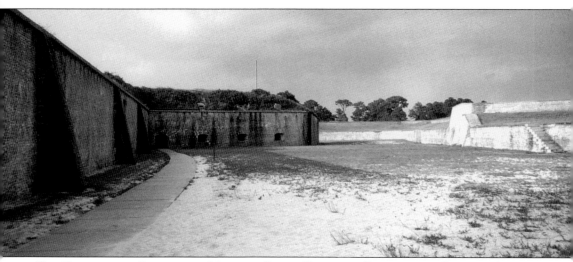

The Exterior of One of the Massive Gorge Bastions, Part of the Curtain Scarp, and Part of the Large Coverface at Fort Pickens. In addition to seven casemated flank guns, each bastion contained magazines and mining tunnels with three chambers. In case the bastion were overrun by attackers, each mining chamber, underneath the terreplein of the bastion, could be packed with as much as 1,000 pounds of black powder and when detonated could dislodge attackers and allow the defenders to regroup.

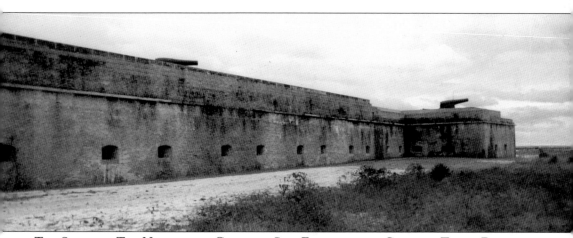

The Scarp of The Northwest Channel Side Face and the Central Tower Bastion at Fort Pickens. The tower bastion was once slightly higher than the curtain scarp and once contained flank guns in its lower tier.

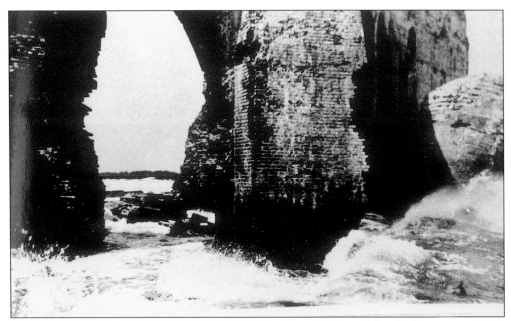

THE SURF BREAKING AGAINST THE RUINS OF OLD FORT MCREE. After the hurricane of 1906 the remnants of the fort disappeared.

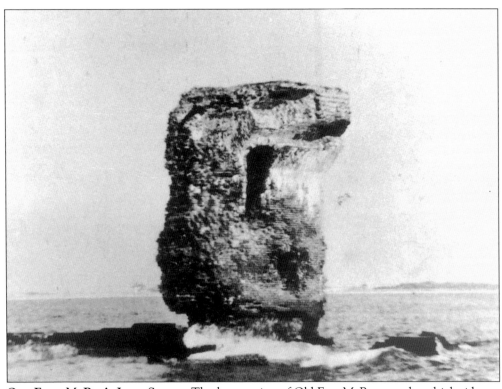

OLD FORT MCREE'S LAST STAND. The last portion of Old Fort McRee stands at high tide.

Four

ENDICOTT BATTERIES

During the period of defense called the Endicott era, modern batteries and weapons were built and installed on the Fort Pickens Reservation and the Fort McRee Reservation. These sub-posts were headquartered at Fort Barrancas. Beginning in 1895, construction began on Battery Cullum. During this period a total of 20 breech loading rifles and 8 powerful rifled BL mortars were mounted in the 10 concrete and earth batteries. Fort Pickens served as the harbor submarine mining depot. In 1902, engineers at Fort Barrancas pioneered a new fire control system that would become known as the Barrancas System.

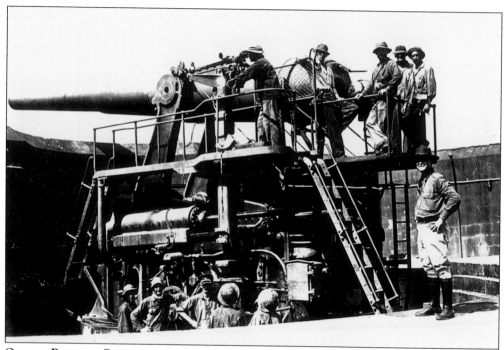

ONE OF BATTERY PENSACOLA'S 12-INCH BL RIFLES ON A DISAPPEARING CARRIAGE BEING READIED TO FIRE. This massive two-gun battery was built on the parade of old Fort Pickens in 1899. Part of the old fort's southwest channel side face and bastion had to be lowered to clear the field of fire for the battery.

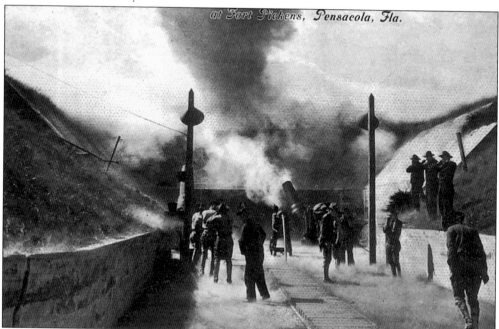

at Fort Pickens, Pensacola, Fla.

FIRING THE 12-INCH MORTARS OF BATTERY WORTH BATTERY WORTH ON THE FORT PICKENS RESERVATION. This two-pit battery once contained eight of these powerful mortars. Four mortars in the battery were removed in WWI.

50

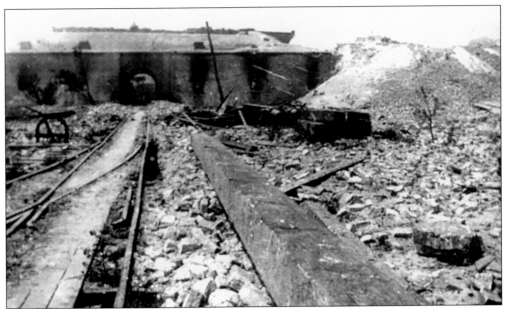

THE MAIN SALLYPORT OF FORT PICKENS SOON AFTER THE FIRE AND MASSIVE EXPLOSION OF JUNE 20, 1899. The northwest bastion of the old fort was completely destroyed; all that remained was a huge pile of rubble. The fire began in a warehouse area and spread to a magazine containing 8,000 pounds of powder. The explosion showered debris over one and one-half miles, reaching as far as Fort Barrancas, across the bay. The tracks run through the sallyport to Battery Pensacola.

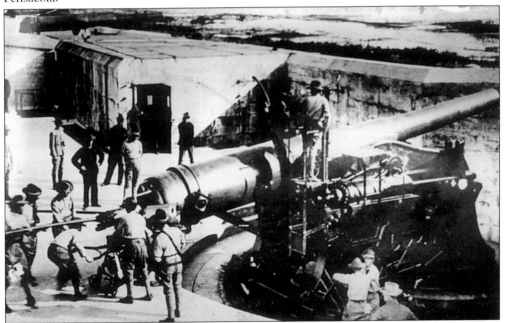

LOADING A 10-INCH BL RIFLE IN BATTERIES CULLUM-SEVIER. Begun in 1895, Batteries Cullum and Sevier once held four 10-inch rifles on disappearing carriages. During WWI, both of Battery Cullum's 10-inch rifles were removed. During WWII, Battery Cullum was modified to mount the two 3-inch rifles of Battery Trueman.

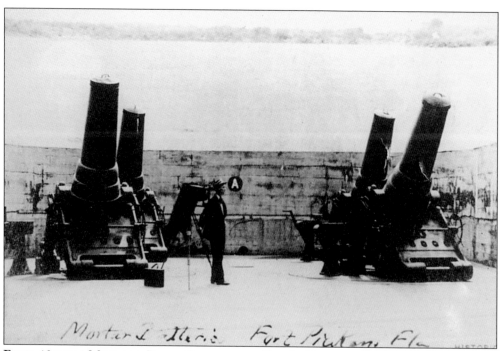

Mortars ... Fort Pickens, Fla

FOUR 12-INCH MORTARS POINT SKYWARD IN PIT A, BATTERY WORTH. Four mortars in the battery would be removed in WWI. The heavy 12-inch mortars had a maximum range of seven to nine miles at 45 degrees elevation and a minimum elevation of one and a quarter miles at 70 degrees elevation. Projectiles weighed between 700 and 1,046 pounds with a 54 pound powder charge.

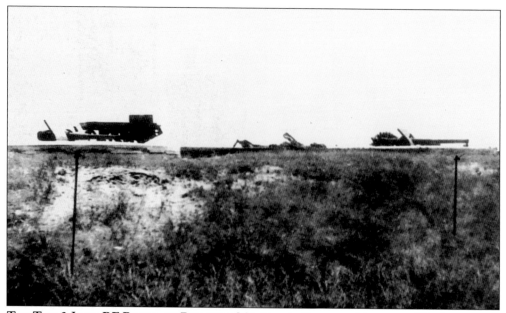

THE TWO 3-INCH RF RIFLES ON PEDESTAL MOUNTS IN BATTERY TRUEMAN. The battery was built in 1905. A 3-inch rapid-fire rifle could fire up to ten rounds a minute. These flat trajectory weapons guarded the submarine mine fields from fast torpedo boats and mine sweepers.

The Second Hospital At the Post of Fort Barrancas. The hospital is seen from the old fort in 1902.

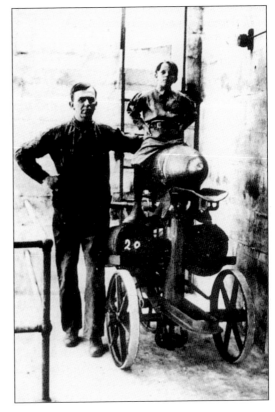

A Shell Cart at Battery Pensacola.
A father and son pose with
a 12-inch shell cart.

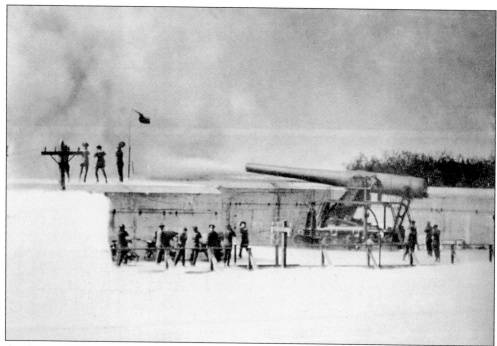

A 12-INCH RIFLE FIRING IN BATTERY PENSACOLA. On disappearing carriages the gun tubes were mounted on one end of a pair of swiveling arms, which were counterweighted at the other end. The counterweights would raise the gun to firing position, and the recoil of firing would push the gun back down to the loading position.

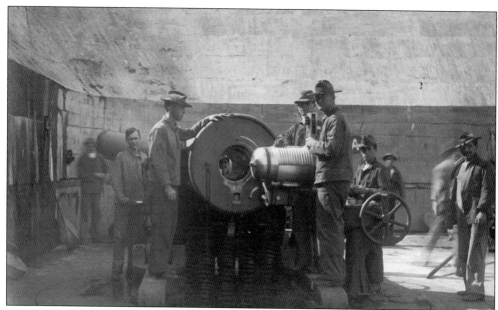

OPENING THE BREECH OF A 12-INCH MORTAR IN BATTERY WORTH. A mortar crew poses with the breech open. Battery Worth was constructed on an isolated area of the Fort Pickens Reservation because, in part, of the tremendous concussion caused by firing the heavy mortars in groups.

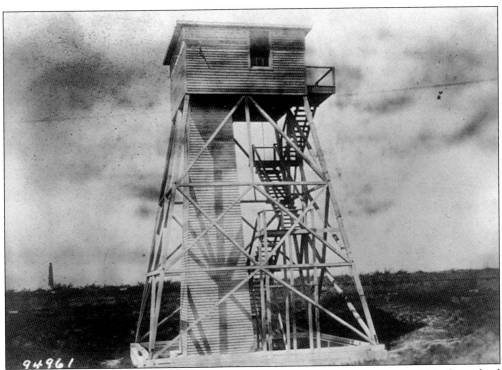

THE BATTERY COMMANDER'S STATION ATOP OLD FORT BARRANCAS IN 1902. Steps lead up to the station and the concrete instrument pedestal is encased in a wooden frame. The Pensacola Lighthouse can be seen in the background.

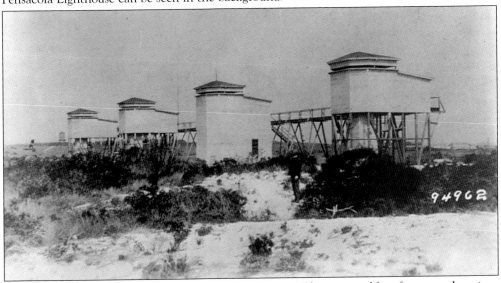

FIRE CONTROL STATIONS OF THE BARRANCAS SYSTEM. This group of four fire control stations built near Fort Pickens was the general fire control station for the Army's experimental fire control system that would come to be known as the Barrancas System. Three of the stations were battery commander's stations, and one was the fire commander's station. All four baselines from the stations were of identical length and azimuth (direction). This horizontal-base system of position finding was successfully tested in 1902.

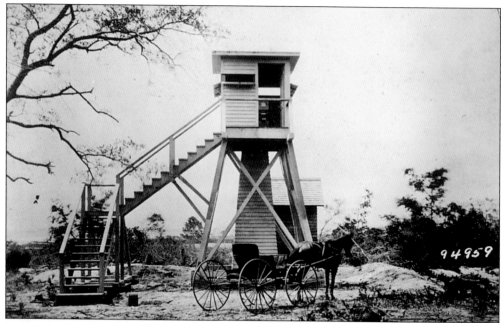

An Experimental Base End Station on Top of the Bluff of the Bay. To accurately aim the guns to hit a moving target at great distances, the principle of triangulation was used. Observations from two known positions, called base end stations, were tabulated at timed intervals to determine the target location and course. The base end station contained several instruments: an azimuth scope, a telephone, and a time interval bell.

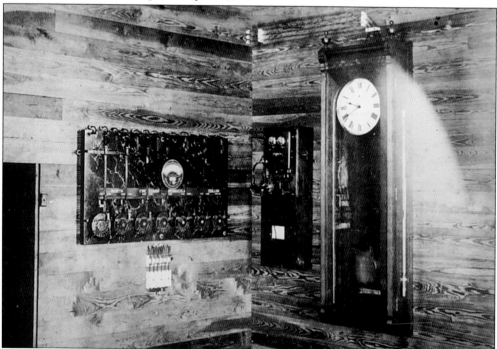

The Interior of a Switchboard Room of the Barrancas System. This view shows the power board, telautograph, telephone, and clock in a switchboard room in 1902.

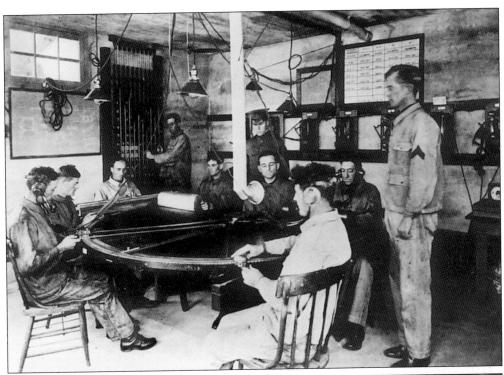

A Typical Range Section Working at a Plotting Board. The plotting board quickly solved the trigonometric problem of locating the target. With an azimuth scale on the outer circle of the 110-degree board, arms set the track of the target by plotting points and allowed the range and azimuth of the target to be predicted.

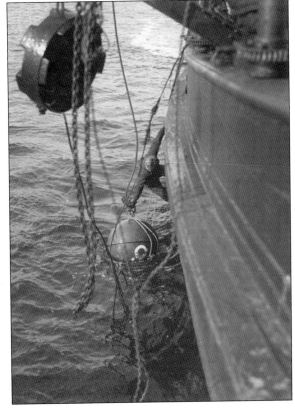

A View from the Side of a Mine Planter During Mine-laying Operations. An anchor is lowered and a man near the water line steadies a mine.

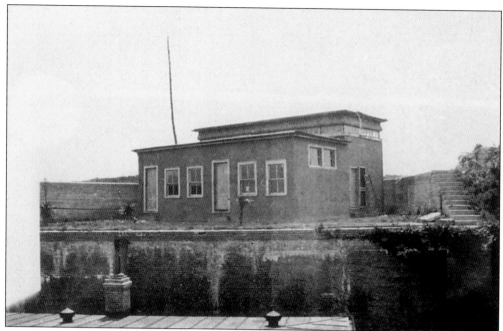

A Combined Command Post Atop Fort Pickens. This station that was once located on top of the northeast gorge bastion of Fort Pickens was a combined mine group command post, gun group command post, and a fire control switchboard. The mining casemate was located below in the ditch and now serves as restrooms for the park.

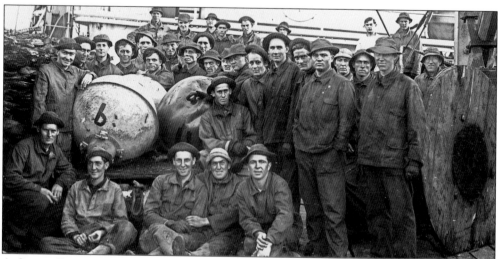

A Scene From the Mining Wharf of Fort Pickens. A mine planter crew poses with mines on the mining wharf of Fort Pickens. The mine planter *General John M. Schofield* is in the background.

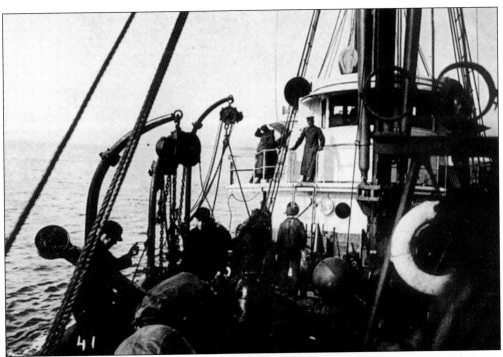

THE BUSY DECK OF A MINE PLANTER VESSEL. Mines and torpedo anchors rest on the deck of a mine planter vessel. Block and tackle on davits lowered and raised the mines and anchors to and from the water.

A MINE STOREHOUSE.

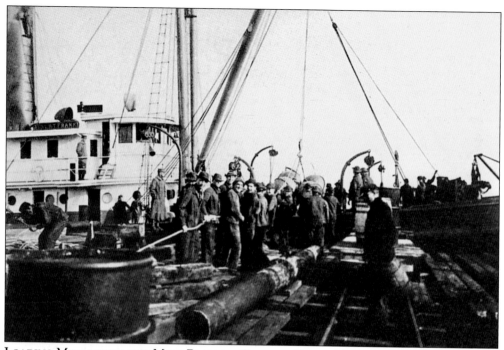

LOADING MINES ONTO THE MINE PLANTER *GENERAL ROYAL T. FRANK.*

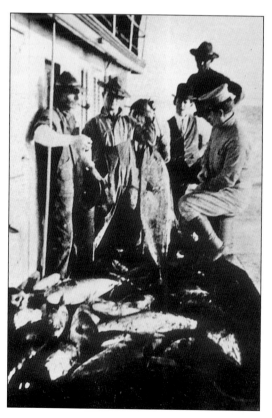

A BOUNTIFUL CATCH. Soldiers proudly display a day's catch of fish on one of the transport vessels.

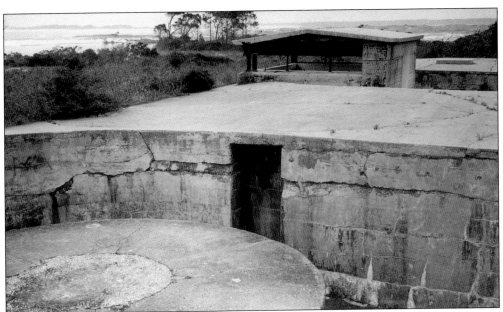

BATTERY VAN SWEARINGEN AS IT APPEARS TODAY. It once mounted two 4.7-inch Armstrong rifles. Battery Van Swearingen, constructed in 1898 and disarmed in 1921, was name in honor of Capt. Joseph Van Swearingen, 6th U.S. Infantry, killed on Christmas Day, 1837, in an engagement with Seminole Indians at Okeechobee, Florida. In 1922, one emplacement was converted into a range-finder station for Battery Payne.

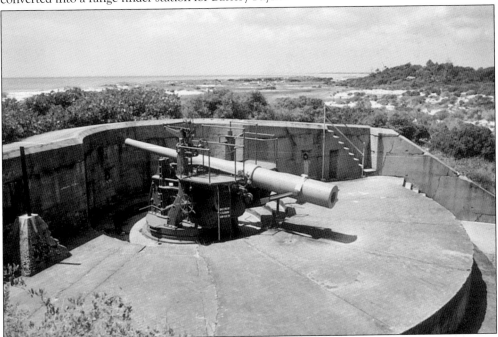

A SIX-INCH BL RIFLE ON A DISAPPEARING CARRIAGE DISPLAYED AT BATTERY COOPER ON THE FORT PICKENS RESERVATION. Battery Cooper once had two of these guns. The battery was named in honor of 2nd Lt. George A. Cooper, who was killed in action on September 17, 1900, by Philippine insurgents at Mavitac in the Province of Laguna.

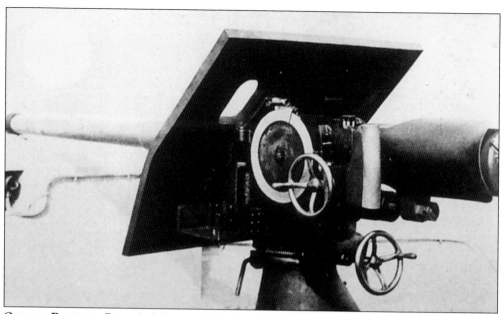

ONE OF BATTERY PAYNE'S MODEL 1902 THREE-INCH RAPID-FIRE RIFLES ON A PEDESTAL MOUNT. The two-rifled battery on the Fort Pickens Reservation was built in 1904. The battery could sweep the inner harbor as well as guard the channel. In 1922, during practice firing, the recoil tore a gun from its mount and hurled it down the steps of the battery, killing Pvt. Hugo W. Paap.

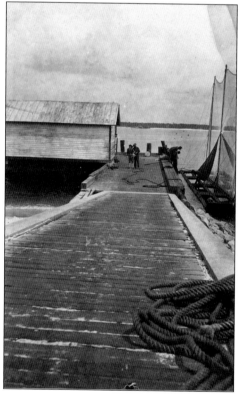

LOOKING DOWN THE QUARTER MASTER'S WHARF AT FORT PICKENS. A view of the wharf includes the boathouse on the left and towed targets on the right.

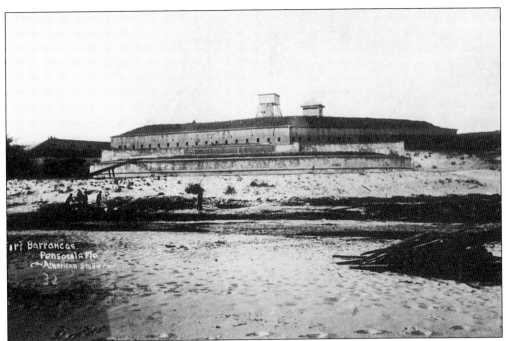

A View of Old Fort Barrancas from Barrancas Beach. In this view from the beach, the water battery is in front of the main works of Fort Barrancas. Atop the fort are the battery commanders station and a secondary station.

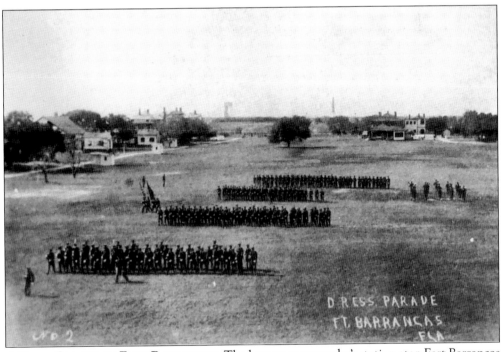

A Dress Parade at Fort Barrancas. The battery commander's station atop Fort Barrancas and the Pensacola Lighthouse can be seen in the distance.

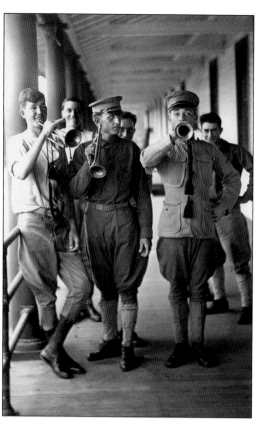

BUGLE PRACTICE ON THE PORCH OF THE BARRACKS AT FORT BARRANCAS.

RELAXING AT THE POST BARBERSHOP. Soldiers in a barbershop read a copy of the *Army and Navy Registry* in 1907.

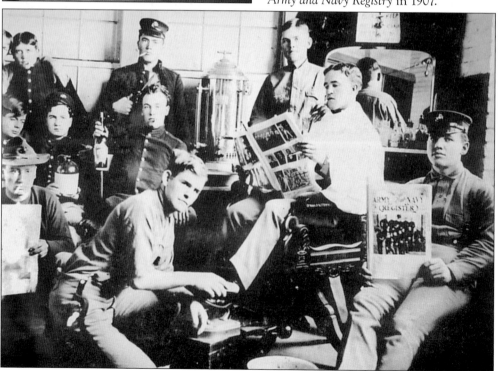

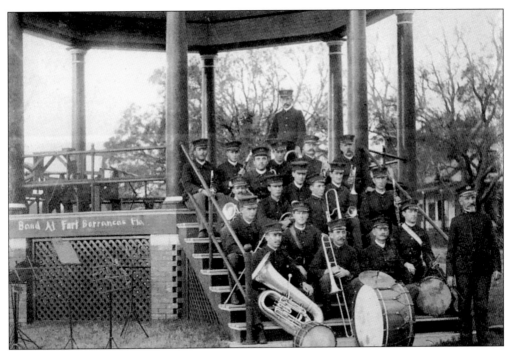

THE FORT BARRANCAS ARMY BAND ON THE PARADE BANDSTAND IN 1907.

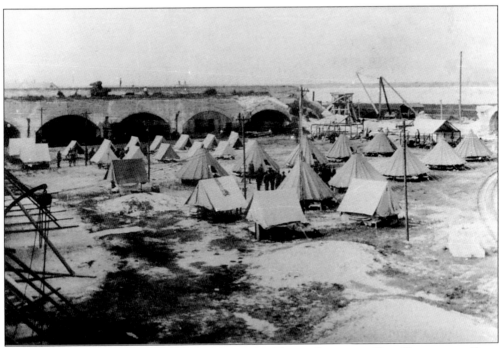

FLORIDA STATE TROOPS BEING INSPECTED AT THEIR CAMP ON THE PARADE OF FORT PICKENS. Soldiers are camped in Sibley tents.

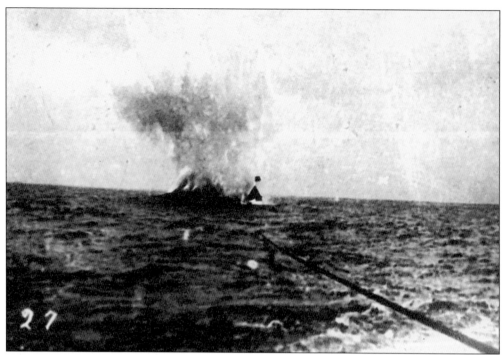

TARGET PRACTICE WITH THE BIG GUNS CAUSES QUITE A SPLASH. This image captures a near miss of a towed target in the Gulf.

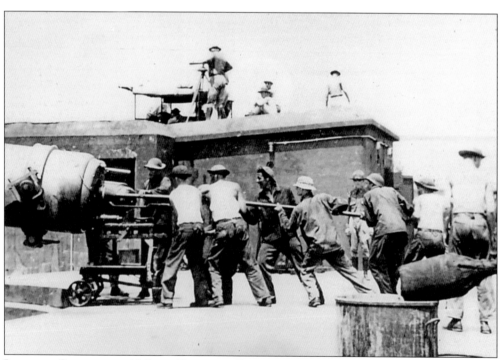

LOADING ONE OF THE 10-INCH RIFLES AT BATTERIES CULLUM-SEVIER. A ramrod was used to slide a shell from the cart into the breech of the tube.

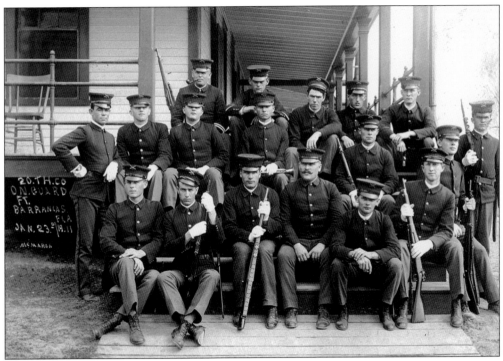

SOLDIERS OF THE 20TH COMPANY ON GUARD AT FORT BARRANCAS IN 1911.

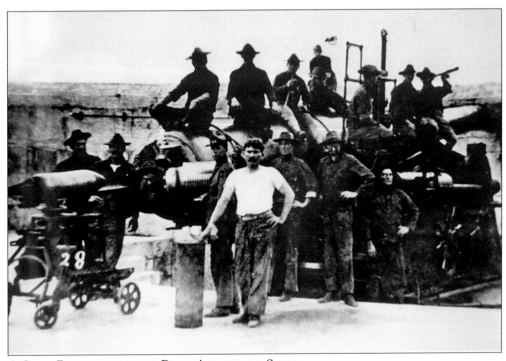

A CREW POSES WITH THEIR RIFLE AWAITING A SHELL.

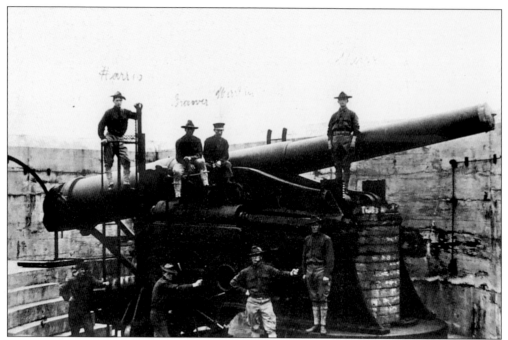

THE BIG RIFLES—IMPRESSIVE BACKDROPS FOR PHOTOGRAPHERS. Artillerymen pose on one of the lowered 10-inch rifles of Batteries Cullum-Sevier. The carriage's counterweight is in raised position.

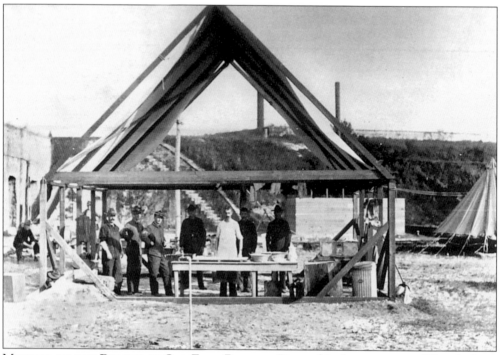

MESSING ON THE PARADE OF OLD FORT PICKENS. Pictured is the mess area of Florida State troops at Fort Pickens.

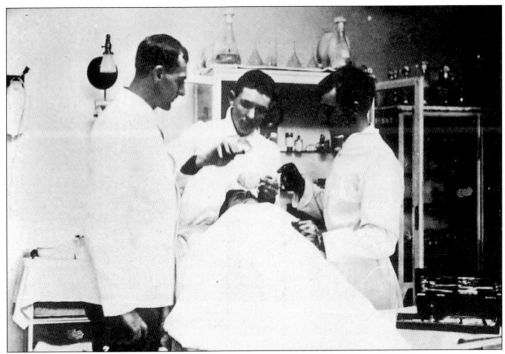

MEDICAL TEAM ADMINISTERS ANESTHESIA AT POST HOSPITAL.

LIFE IN THE CAMPS. Soldiers camped on the parade of Fort Pickens in Sibley tents.

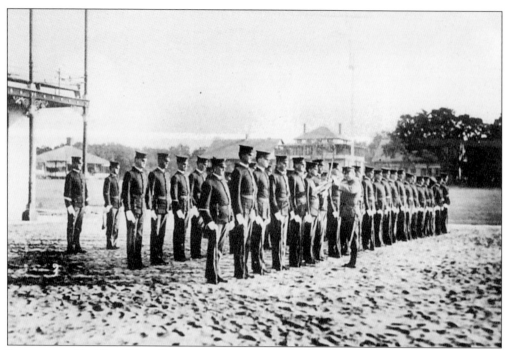

INSPECTION OF THE 20TH COMPANY COAST ARTILLERY. The company stands at attention for an inspection.

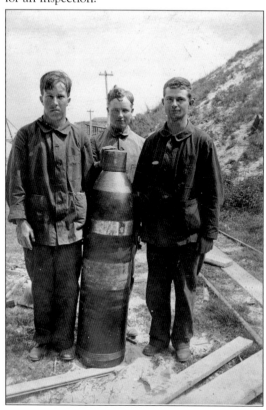

THE 12-INCH SHELLS WERE HUGE. Men pose with a 12-inch shell at Fort Pickens.

THE ARMY'S 12-INCH RIFLES—THE LARGEST MANUFACTURED DURING THE ENDICOTT-ERA. Artillerymen pose in front of #2 rifle of Battery Pensacola with the breech open. A man is in the 12-inch tube. The rifle had a range of less than eight miles at 10 degrees elevation.

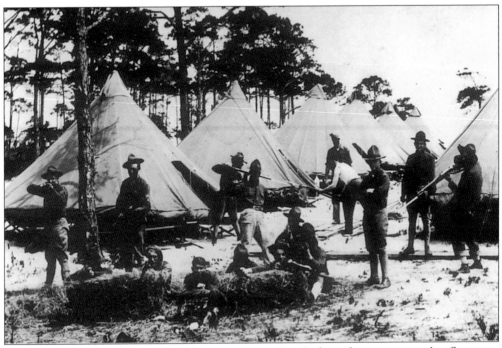

CAMP FUN AT FORT PICKENS. Soldiers in camp at Fort Pickens demonstrate with rifles.

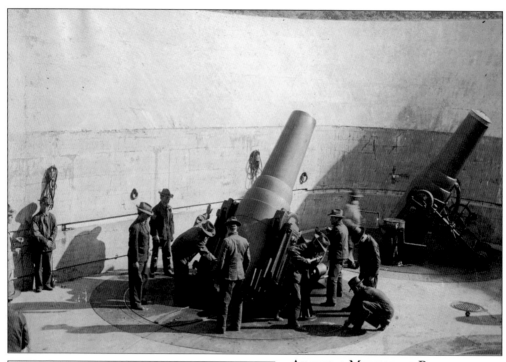

AIMING A MORTAR AT BATTERY WORTH. When the mortars were fired in groups, a shotgun-like pattern of high trajectory, plunging fire would have been effective in piercing through the decks of enemy ships.

THROWING A "BLANKET PARTY" AT FORT PICKENS. Troops often created their own entertainment.

SWIMMING AT THE BEACH NEAR FORT PICKENS.

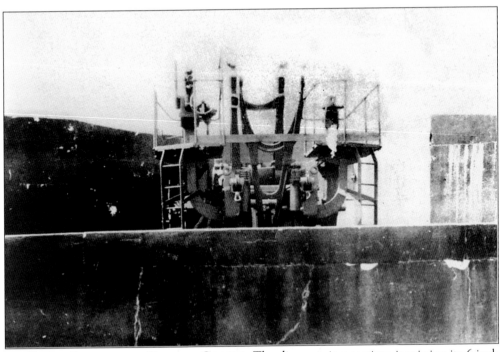

AN EMPTY CARRIAGE AT BATTERY COOPER. The disappearing carriage is missing its 6-inch tube. The 6-inch rifle had a range of about 9 miles at 15 degrees elevation.

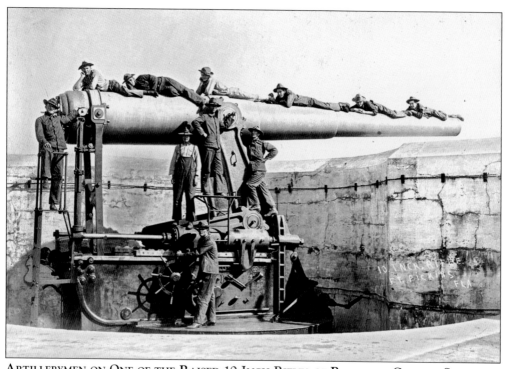

ARTILLERYMEN ON ONE OF THE RAISED 10-INCH RIFLES OF BATTERIES CULLUM-SEVIER.

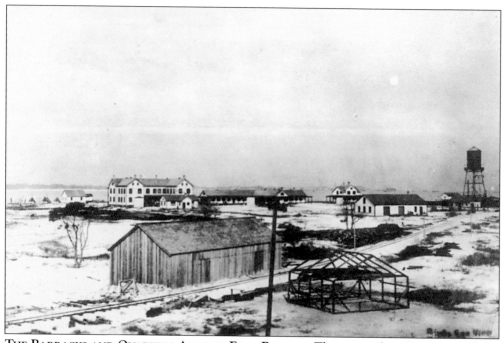

THE BARRACKS AND QUARTERS AREA OF FORT PICKENS. The view is from Batteries Cullum-Sevier toward the bay. The main two-story barracks burned to the ground in 1940.

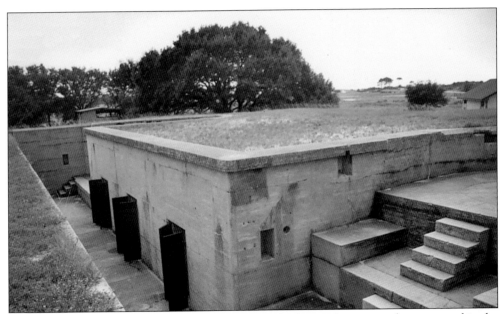

THE MAGAZINES OF BATTERY TRUEMAN. The steps lead up to the gun emplacement and in the background is the battery commander's station.

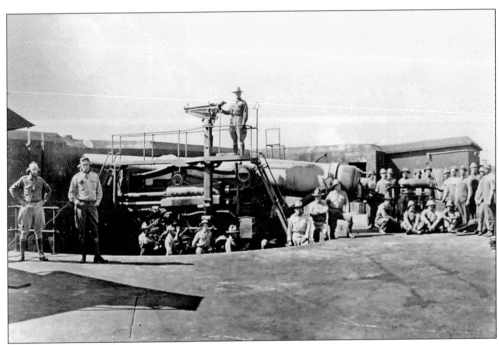

LOADING A 10-INCH RIFLE AT BATTERIES CULLUM-SEVIER.

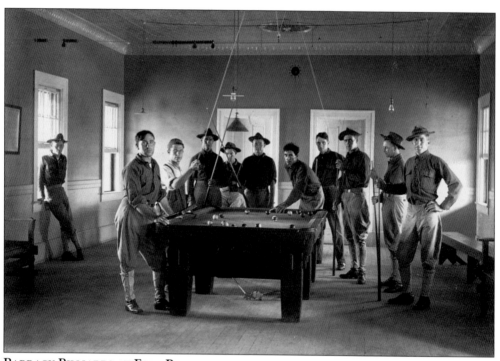

BARRACK BILLIARDS AT FORT BARRANCAS.

A CLOSED 12-INCH MORTAR BREECH.
A crew poses on the #2 mortar of one of
the pits in Battery Worth.

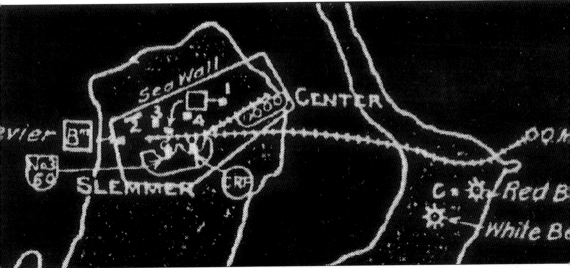

A Map of the Fort McRee Reservation with Battery Slemmer and Battery Center. Surrounded by a sea wall, the reservation also contained quarters, barracks, an engineer's storehouse and a quartermaster's coal shed. A narrow-gauge railway connected the post to the quartermaster's wharf on the pass. At Battery Slemmer were a 60-inch searchlight and a coincidence range finder (CRF) station.

An Old Instrument Pedestal at Fort McRee. This is a view of an old instrument pedestal that was once a base end station for Battery Sevier and a portion of the seawall that surrounds the gun batteries on the Fort McRee Reservation.

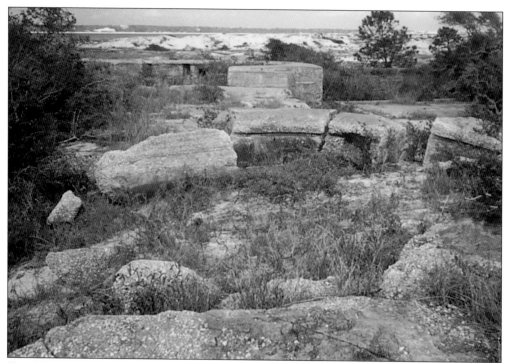

THE MOSTLY BURIED RUINS OF THE FOUR EMPLACEMENTS FOR THREE-INCH RAPID-FIRE RIFLES ON MASKING PARAPET MOUNTS IN BATTERY CENTER. Battery Center was constructed in 1901 and disarmed in 1920. Battery Center was named in honor of Lt. J.P. Center, adjutant, 6th U.S. Infantry, who was killed in the battle of Okeechobee, Florida, on December 25, 1837.

THE ALMOST BURIED CONCRETE PARAPET OF BATTERY SLEMMER THAT ONCE HELD TWO EIGHT-INCH BL RIFLES. Battery Slemmer was constructed in 1900 and disarmed in 1918. Battery Slemmer was named in honor of Lt. Col. Adam J. Slemmer, 4th Infantry, who commanded Fort Pickens during the "stand off" in 1861.

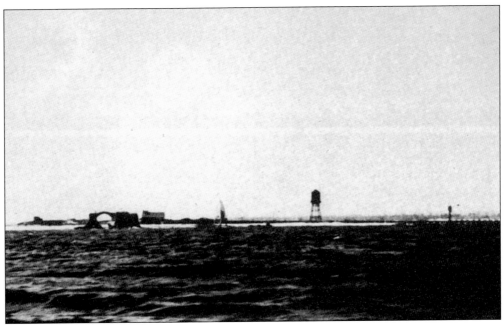

THE FORT MCREE RESERVATION AS SEEN FROM THE PASS BEFORE 1906.

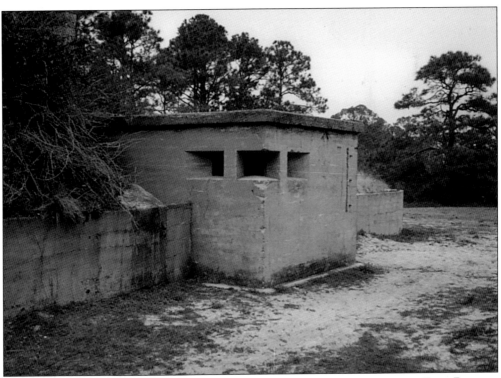

THE DATA BOOTH FOR ONE OF THE MORTAR PITS AT BATTERY WORTH ON THE FORT PICKENS RESERVATION. A slate board slid through the slot in the wall with directions for elevation, azimuth (direction), and zone of fire written on it.

IN THE BARRACKS WITH DRESS UNIFORM. A soldier displays his rifle with fixed bayonet.

LOOKING EAST FROM THE BATTERY COMMANDER'S STATION ATOP OLD FORT BARRANCAS. In this view of the Fort Barrancas Post parade ground and officers' row Barrancas Barracks can be seen in the distance.

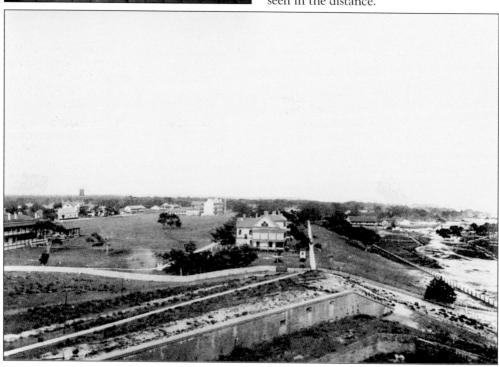

Five

THE WORLD WARS

In 1917 at the Fort Pickens Reservation, work began on Battery Langdon that would mount two powerful 12-inch rifles on barbette carriages. The harbor was guarded by the 13th Coast Artillery Regiment. Starting in 1921, Fort Barrancas would host the Citizens' Military Training Camps (CMTC). In 1937, four 155mm GPF batteries were installed on Panama mounts around the old Battery Cooper. During WWII, Battery Langdon was casemated. The two 3-inch rifles of Battery Trueman would be mounted on Battery Cullum. The Harbor Defense Command Post and Harbor Entrance Control Post were built in to the old mortar Battery Worth. Two 90mm ATMB batteries were mounted on the other side of the seawall between Battery Cullum and Old Fort Pickens. Two 6-inch shield gun batteries were constructed on the Fort Pickens (Battery 234) and Fort McRee (Battery 233) Reservations.

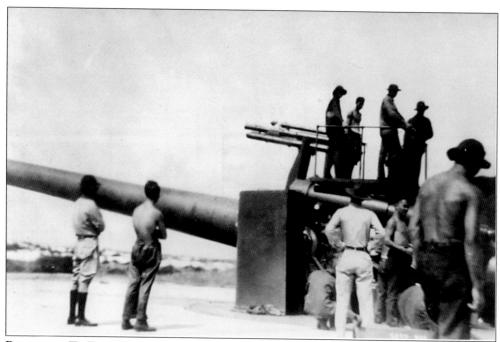

PREPARING TO FIRE ONE OF THE 12-INCH BARBETTE RIFLES AT BATTERY LANGDON. Battery Langdon was named for Brig. Gen. Loomis L. Langdon. Langdon came to Fort Pickens as a young lieutenant during the Civil War and died on January 7, 1910.

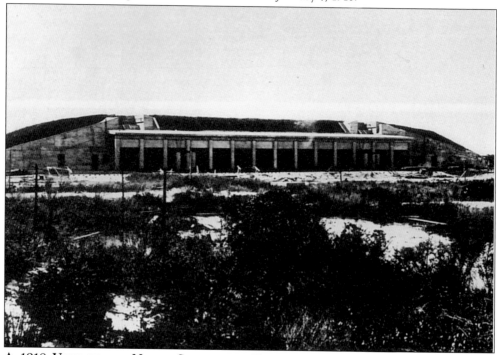

A 1918 VIEW OF THE NORTH SIDE OF THE TRAVERSE OF BATTERY LANGDON WITH ITS CONCRETE WORKS. The traverse contained powder magazines and shell rooms. On each side was a store room and a plotting room for each gun.

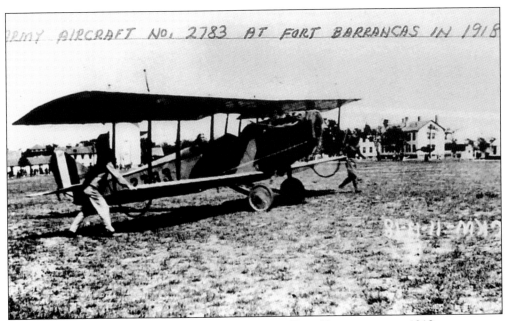

A CURTIS JN-4 JENNY BIPLANE ON THE PARADE OF FORT BARRANCAS IN 1918.

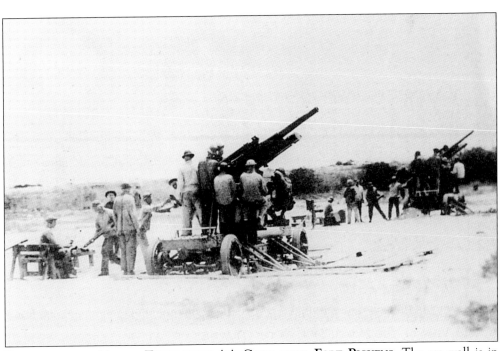

PRACTICE WITH MOBILE THREE-INCH AA GUNS NEAR FORT PICKENS. The sea wall is in the background.

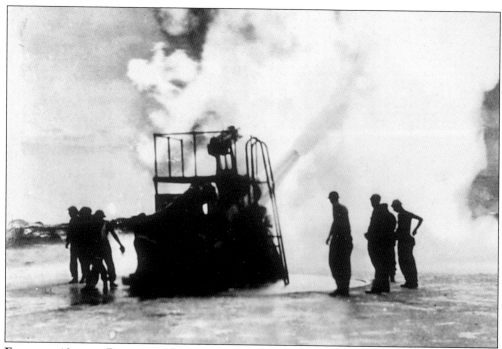

FIRING A 12-INCH BARBETTE GUN OF BATTERY LANGDON. The shock waves from the blast would send ripples through the sand.

THE GUN CREW OF ONE OF THE RIFLES AT BATTERY LANGDON. The gun crew is in front of a 12-inch barbette rifle of Battery Langdon.

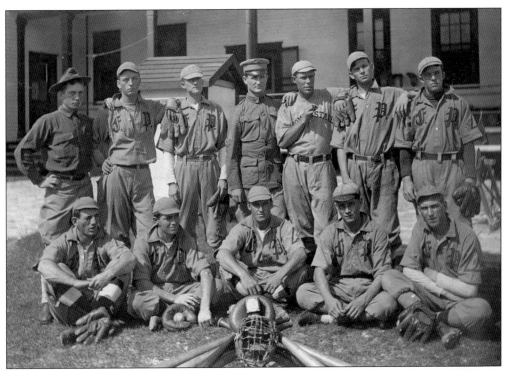

THE FORT PICKENS BASEBALL TEAM. The players proudly pose in their uniforms and display their baseball equipment.

CALISTHENICS AT FORT PICKENS. Troops exercise with a medicine ball. The heavy leather ball was tossed from man to man to build upper body strength

AN AERIAL VIEW OF FORT BARRANCAS WITH AN OLD INSTRUMENT PEDESTAL AND RADIO MAST ON THE PARADE.

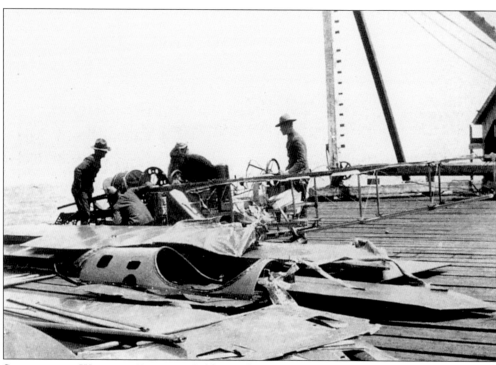

SALVAGING A WRECKED BIPLANE. Soldiers salvage pieces of a wrecked plane on Santa Rosa Island in 1918. During the early years of aviation, aircraft were largely experimental and many crashed on or near Santa Rosa Island.

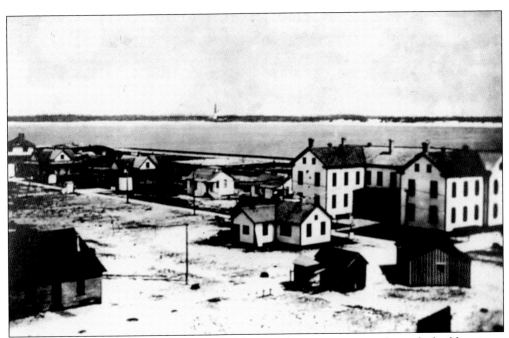

A View of The Post of Fort Pickens in 1919. The main two-story barracks building is on the right. The Pensacola Lighthouse can be seen on top of the bluff across the bay.

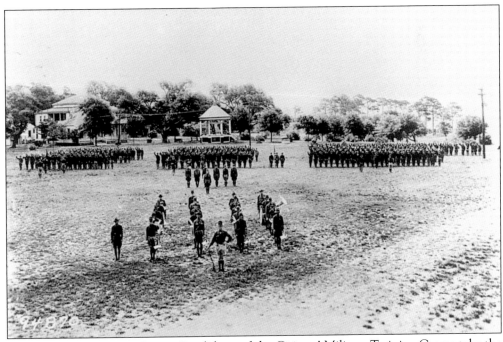

Candidates Take the Oath. Candidates of the Citizens' Military Training Camps take the Oath of Allegiance on the Fort Barrancas parade ground in 1925. The CMTC were held during the summer to train young volunteers. After the completion of four camps a candidate could be eligible for a commission in the Officers' Reserve Corps.

CANDIDATES ON ONE OF THE BIG GUNS. CMTC candidates pose on one of the 10-inch BL rifles of Battery Sevier in 1925. Lying about his age, Oscar W. Medley first came to the CMTC at Fort Barrancas in 1930 at the age of 16. He returned each summer to complete the four camps and received a recommendation for a commission. Because he lacked trigonometry credits his commission was denied. Undaunted, Medley in 1936 joined the Army anyway and became a sergeant at Fort Barrancas.

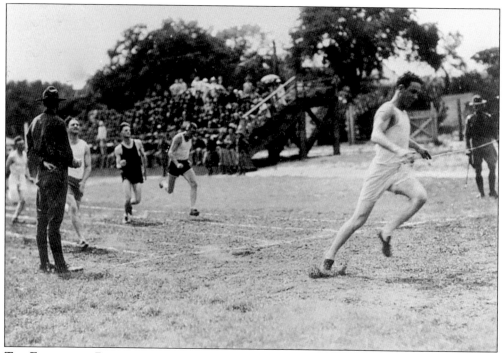

THE FINISH OF A RACE AND GRAND STAND AT A CMTC TRACK MEET AT FORT BARRANCAS IN 1925. Competition between the various batteries was fierce.

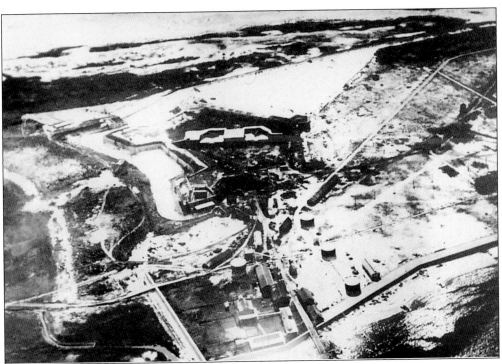

HIGH ABOVE FORT PICKENS. This is an aerial view of the Fort Pickens maintenance area.

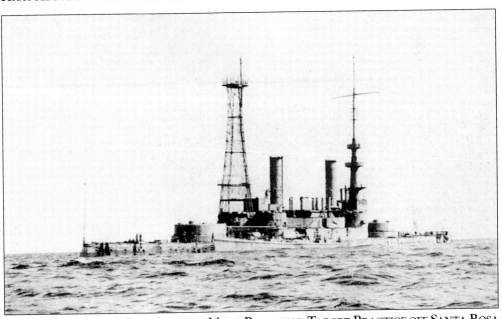

THE SCUTTLED USS MASSACHUSETTS MADE READY FOR TARGET PRACTICE OFF SANTA ROSA ISLAND. The obsolete battleship was towed to Pensacola for artillery trials. A 12-inch railway gun and 12-inch railway mortar were moved to Pensacola for the test. The mortars of Battery Worth and the 12-inch guns of Battery Pensacola also fired on the ship. Test firing began on January 6 and concluded on January 18, 1921. Twenty-one shells from the four batteries hit the ship.

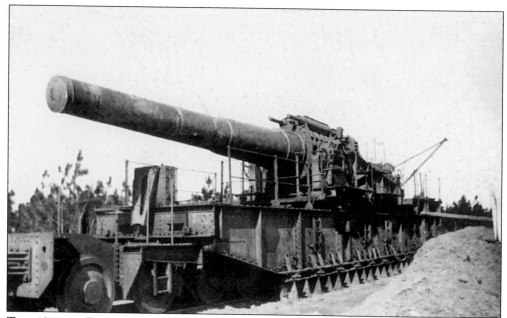

THE 12-INCH RAILWAY GUN BROUGHT TO PENSACOLA FOR TARGET PRACTICE ON THE USS MASSACHUSETTS.

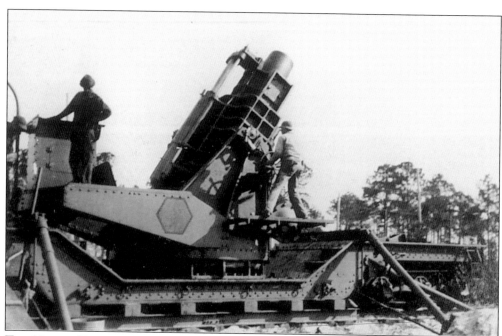

THE 12-INCH RAILWAY MORTAR THAT FIRED ON THE USS MASSACHUSETTS.

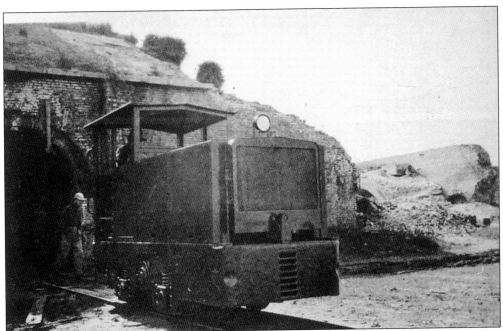

AN AMMO TRAIN ON NARROW GAUGE TRACKS. An ammo train engine emerges out of old Fort Pickens' sallyport in 1918. The pile of debris was left over from the massive explosion of 1899.

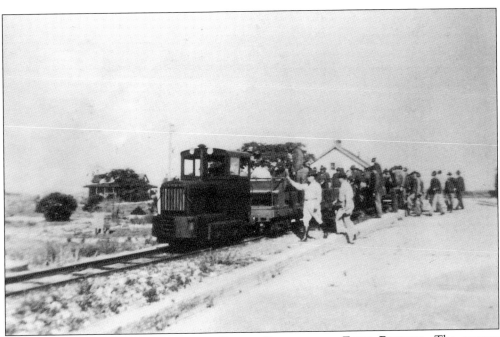

TROOPS EMBARK ON THE NARROW GAUGE RAILWAY AT FORT PICKENS. The narrow gauge railway on the Fort Pickens Reservation moved troops, supplies, equipment, mines, and ammunition.

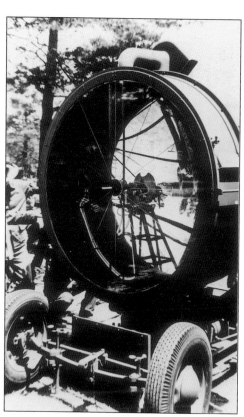

A 1941 Photo of a Mobile 60-inch Searchlight. Illumination of the pass and the offshore waters of the Gulf at night was important for a proper defense of the harbor.

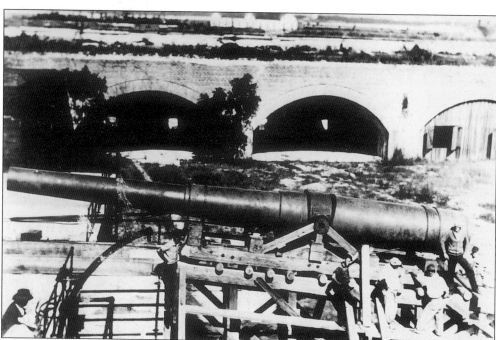

One of the Tubes of Battery Pensacola Being Removed in 1934. The casemates in old Fort Pickens are visible in the background.

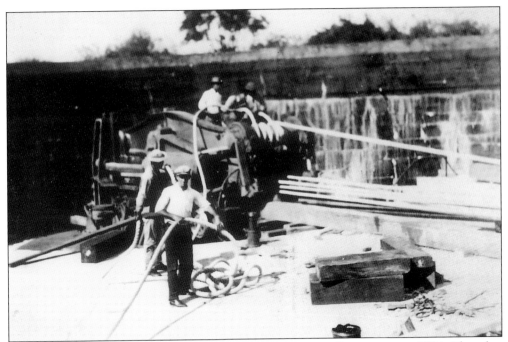

WINCHING DOWN ONE OF THE 12-INCH TUBES OF BATTERY PENSACOLA IN 1934. The tubes were rolled down a wooden ramp.

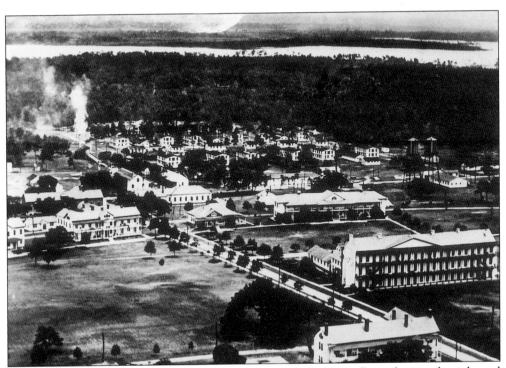

A 1934 AERIAL VIEW OF THE FORT BARRANCAS POST. Barrancas Barracks is to the right and Bayou Grande is at the top of the photo.

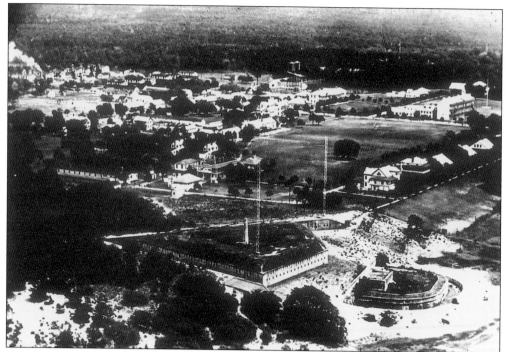

AN AERIAL VIEW OF OLD FORT BARRANCAS AND THE POST LOOKING EAST. Situated on a bluff overlooking the blue waters of the bay, the post of Fort Barrancas was beautiful. The army closed the post in 1947. Today, most of the old post is used by Naval Air Station Pensacola.

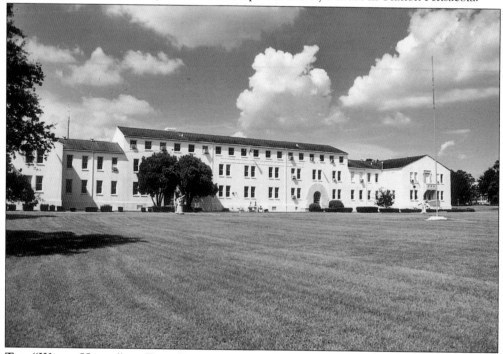

THE "WHITE HOUSE" AT FORT BARRANCAS. In 1939, a new enlisted barracks known as the "White House" was completed at Fort Barrancas.

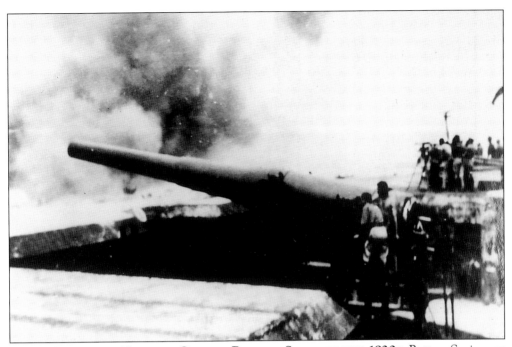

FIRING ONE OF THE TEN-INCH GUNS OF BATTERY SEVIER IN THE 1930S. Battery Sevier was named in honor of Brig. Gen. John Sevier, who died on September 24, 1815.

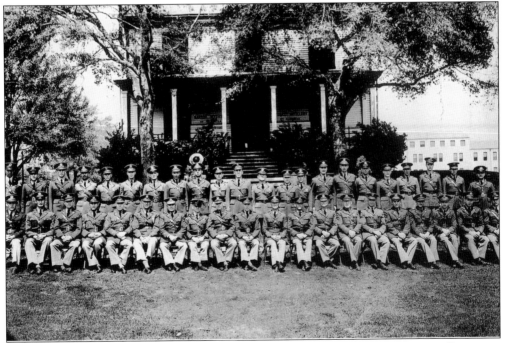

A GROUP OF OFFICERS OF FORT BARRANCAS IN FRONT OF THE HEADQUARTERS BUILDING IN 1939.

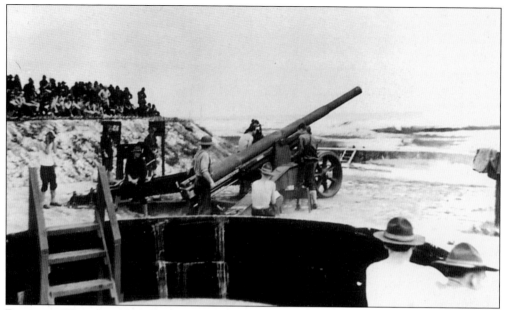

PRACTICE WITH A 155MM RIFLE. In 1941, a ROTC crew trains on a 155mm. Instructors look on from an empty emplacement of Battery Van Swearingen. Spectators look on from the slope of Battery Sevier.

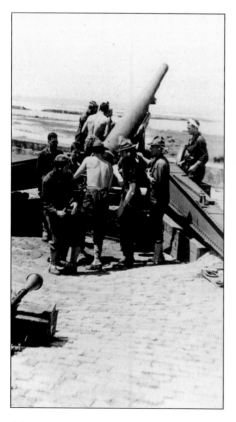

LOADING A 155MM RIFLE. ROTC students are loading a 155mm gun in 1941. John Middlebrooks tells of firing the 155mm rifles at towed targets in the Gulf at the CMTC in the summer of 1935. Short on gun crews, some of the Basic trainees were given a manual to study and then tested. The trainees with the highest scores were put on the gun crews. At least half the gun crews were made up of these green Basic candidates, who did not know what to expect when the big guns were fired. The new crewmembers were told wild stories of what to expect. The crews trained hard in anticipation of the day they would fire live ammo. On the day the guns were fired the crew were wearing the old and well-worn blue denim fatigues. Middlebrooks said, "Everyone did his job well, but when the gun fired with a big blast, half the gun crew took off over the sandbag parapet and scattered like a covey of quail. It took about 10 minutes to get them assembled again. All had a tale to tell as to what happened to them. One had his fatigue top blown off, one had his pant leg torn up to the knee. Some said they were blown down, and some were scratched a bruised. We were all in trouble, but after it was over, it was real funny and provided many hours of enhanced conversation."

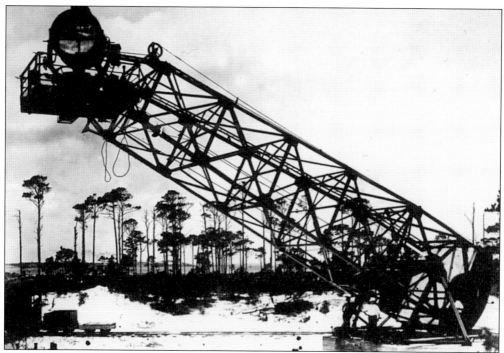

A Searchlight Tower Being Lowered. At the bottom is a large counterweight. To illuminate the channel into the bay and the offshore waters of the Gulf at night, seven large 60-inch searchlights were used in World War II. This searchlight was mounted on a 60-foot steel tower that could be pivoted and lowered with the help of counterweights. During the day, the searchlights were lowered.

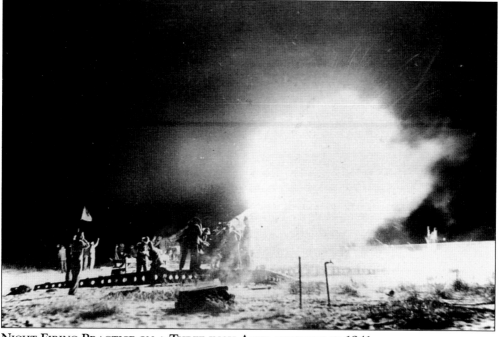

Night Firing Practice on a Three-inch Anti-aircraft in 1941.

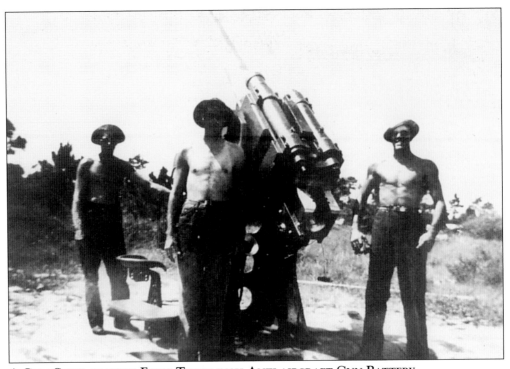

A Gun Crew at their Fixed Three-inch Anti-aircraft Gun Battery.

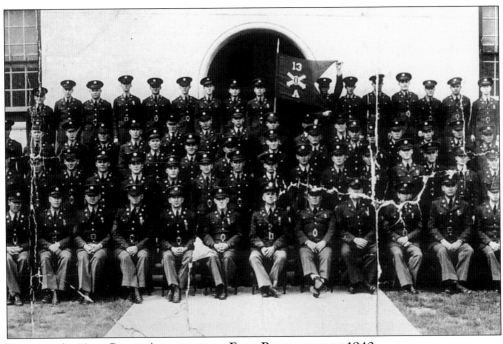

Battery A, 13th Coast Artillery, at Fort Barrancas in 1940.

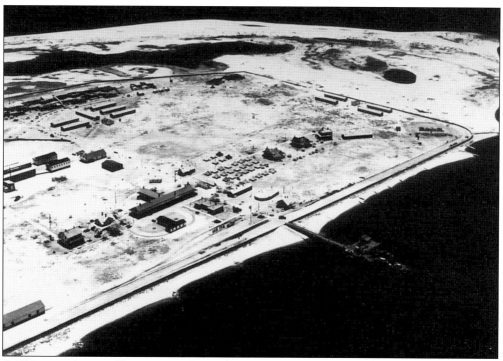

A 750-FOOT AERIAL VIEW OF THE FORT PICKENS RESERVATION IN 1942. A road ran from the wharf to Batteries Cullum-Sevier.

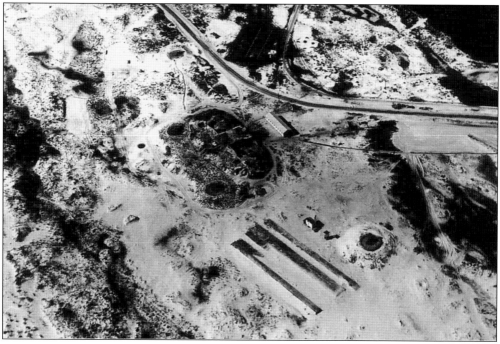

AN AERIAL VIEW OF BATTERY COOPER WITH FOUR GPF 155MM GUN BATTERIES ON PANAMA MOUNTS IN 1942.

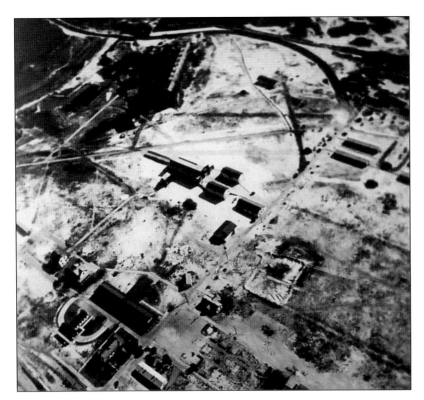

The old fort can be seen on the top left corner.

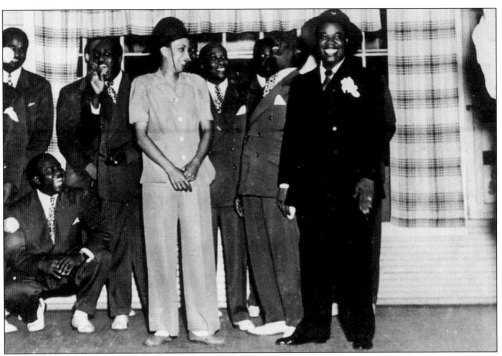

Louis Armstrong and his Band at Fort Barrancas in 1942. On Friday nights, drivers in vehicles from the motor pool would drive women in Pensacola to dances at the Post.

THE FORT BARRANCAS THEATRE.

THE FORT BARRANCAS MOTOR POOL WITH TRUCKS ON EACH SIDE.

A Military Wedding at the Fort Barrancas Chapel in 1943. Over the years, many soldiers and sailors married local women.

The HDCP And HECP At Battery Worth. In WWII, the combined harbor defense command post and harbor entrance control post was constructed in Battery Worth. These command posts were jointly operated by the Army and Navy. In the bottom level were Army and Navy radios, quarters, fire control switchboard, generator room, etc. Airlocks made the station gas proof. The two-story observation station on top had a chart room on the first floor, instruments on the second floor, and an observation deck on top.

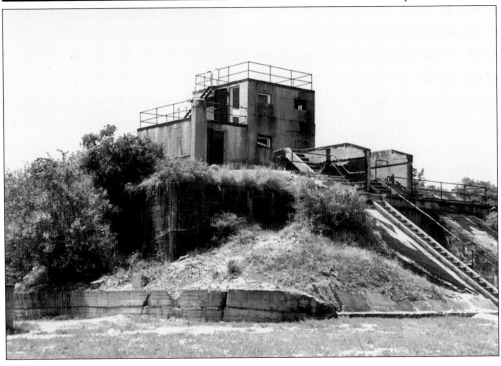

A Jeep At Fort Barrancas. A soldier leans on a jeep at Fort Barrancas in 1942.

One of Fort Barrancas' Fire Trucks. Cpl. Robert LeSueur poses next to one of the Fort Barrancas fire trucks in the 1940s.

An Entrance to Battery 233 at the Fort McRee Reservation.

Aerial View of Construction of Battery 233 on Fort McRee Reservation, 1944.

THE DUAL RANGE-FINDING AND BATTERY COMMANDER'S STATION FOR WORLD WAR II BATTERY 234.

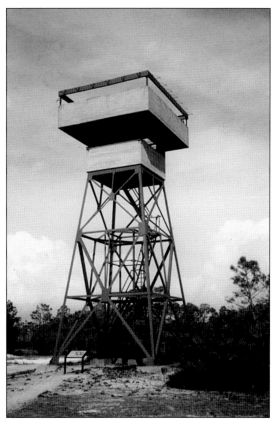

A SHIELDED WWII SIX-INCH GUN DISPLAYED AT BATTERY 234 ON THE FORT PICKENS RESERVATION. These 200-series dual-gun, earth-covered concrete batteries used a standard design with minimum variations. With barbette gun emplacements and entrances on each side of the large mound, a common corridor led to inner powder rooms, shell rooms, a plotting room, a power room, water cooler room, storage rooms, radio, and spotting room. Fuel tanks were buried behind the mounds. Four-inch thick cast-steel shields protected the gun crews from machine-gun fire and near misses from naval bombardment. Each gun and shield weighed 80 tons. Battery 233 was constructed at the Fort McRee Reservation. In the case of both batteries, only the barbette carriages were ever installed. For demonstration purposes, the National Park Service moved the two guns to Battery 234.

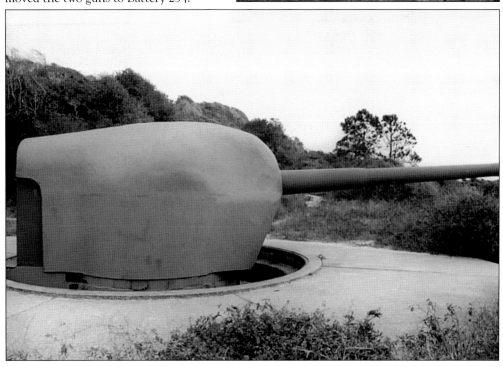

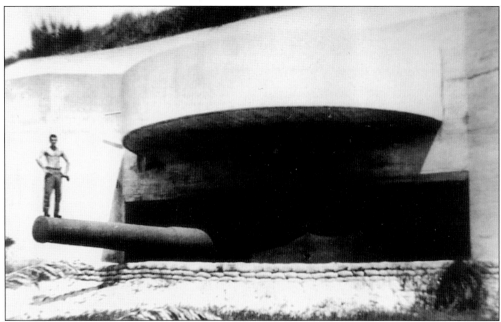

A Casemated Battery Langdon. This is a WWII view of one of the gun canopies and a soldier on one of the 12-inch rifle tubes of Battery Langdon. Battery Langdon was constructed in 1917 with open firing platforms for two guns. During WWII, the battery was casemated with 17-foot- thick concrete. Battery Langdon's guns could throw a projectile 17 miles out to sea.

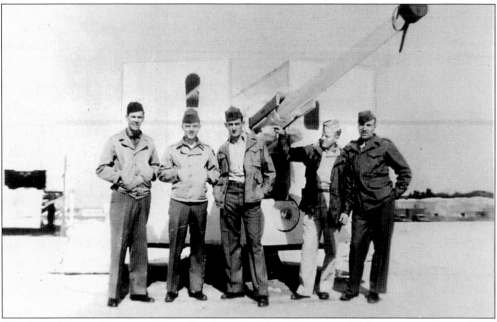

An Anti Motor Torpedo Boat Battery At Fort Pickens. Soldiers pose in front of one of the 90mm AMTB rifles in 1945. Two of these dual-purpose rifles were mounted on concrete blocks on the Gulf side of the seawall between Battery Cullum and old Fort Pickens. Igloo magazines were built into the slope of Battery Cullum and along the south face of the old fort. The men are identified as Kania, Copenhauer, Yanavok, Cool, and Maltempal.

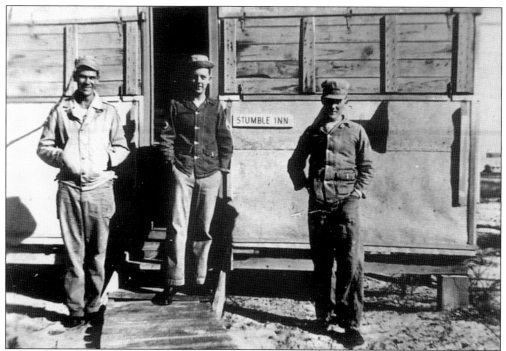

HOME SWEET HOME. Soldiers at Fort Pickens pose in front of their billet called the "Stumble Inn." They are identified as Kania, Copenhauer, and Warner.

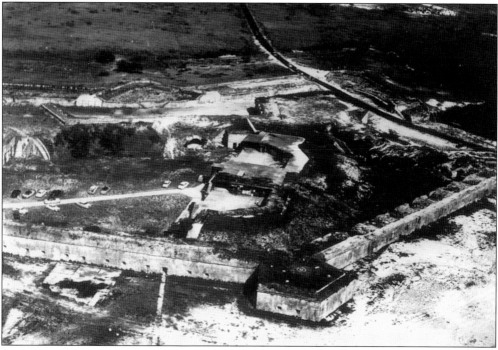

AN AERIAL VIEW OF FORT PICKENS, 1950s. The large, concrete Endicott-era Battery Pensacola is in the center of the old fort's parade. The battery once held two 12-inch rifles on disappearing carriages. In front is the center tower bastion of the old fort.

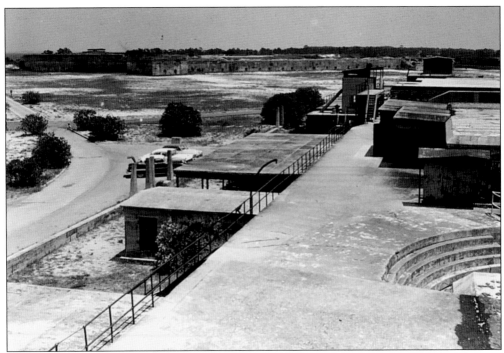

A VIEW OF FORT PICKENS STATE PARK, FROM BATTERIES CULLUM-SEVIER LOOKING TOWARD OLD FORT PICKENS.

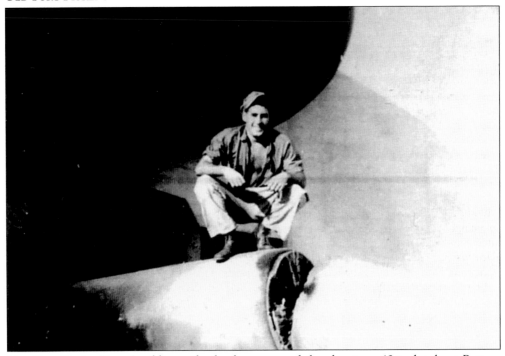

THE END OF AN ERA. A soldier smiles for the camera while salvaging a 12-inch tube at Battery Langdon on September 16, 1947. One wonders if the soldiers realizes it is the end of the coast artillery era.

Six

NAVAL AIR
STATION PENSACOLA

In 1913, the old Pensacola Naval Yard was selected as the location for the first Aeronautic Center. In April 1914, nine Navy officers and twenty-three sailors from the USS Mississippi and the USS Orion landed at the Old Navy Yard to set up a flying school. The first instruction was conducted with seven early seaplanes. Lt. John H. Towers, Naval Aviator Number 3, was in charge of instruction, and Lt. Cmdr. Henry C. Mustin, Naval Aviator Number 11, commanded the Aeronautic Station. Experimentation with lighter than air balloons and airships were later added to the course.

World War I brought with it much innovation in aircraft design. During that war there was a great increase in the number of men trained at the Naval Air Station. The war also brought about the use of seaplanes, as well as land-based aircraft. Land-based aircraft were flown from Chevalier Field, just outside the north wall of the Old Navy Yard. In 1923, Corry Station was built north of Pensacola and was relocated to its present site in 1928.

World War II brought an increase in all naval training activities. During the war, 4,000 British and Commonwealth pilots were trained at the base. By 1944 an all-time high of 12,010 men completed training and flew a combined total of almost two million hours. During the early 1940s, the station added two more airfields: Saufley Field and Whiting Field.

Sherman Field was built to handle the higher airspeeds of the jet age and was dedicated November 2, 1951. Today, the field is home to the famous Blue Angels (the Navy's Flight Demonstration Squadron) and Training Air Wing Six.

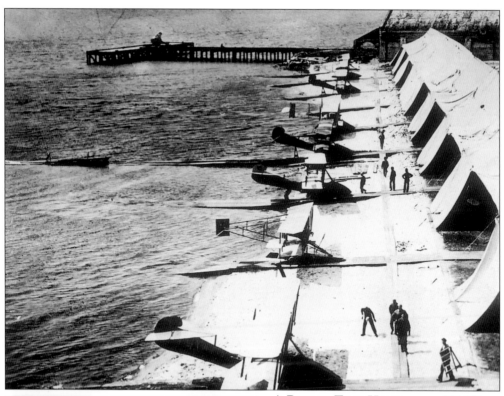

A ROW OF TENT HANGARS AT NASP.
The first amphibious aircraft were
hangared in tents. Wooden ramps were
used for the seaplanes to reach the water.
The second plane is the Curtiss A-1 Triad,
the Navy's first successful seaplane.

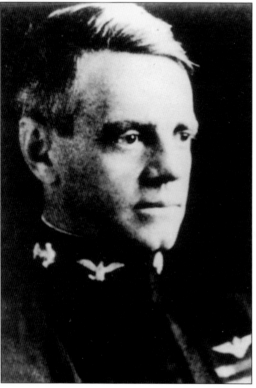

COMDR. HENRY C. MUSTIN. Commander
Mustin became the first base commander
of NAS Pensacola in 1914.

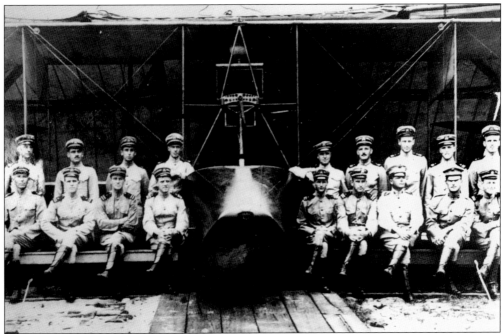

THE FIRST AVIATOR CLASS AT NAS PENSACOLA IN 1915. They are, from left to right, (front row) Richard C. Saufley, Patrick N.L. Bellinger, Kenneth Whiting, Henry C. Mustin, Albert C. Read, Earle F. Johnson, Alfred Austell Cunningham, Francis T. Evans, and ? Haas; (back row) Robert R. Paunack, Earl W. Spencer Jr., Harold T. Bartlett, ? Edwards, Clarence K. Bronson, William M. Corry, ? Norfleet, Edward O. McDonnell, and Harold W. Scofield. The aircraft in back is a Curtiss MF-Boat.

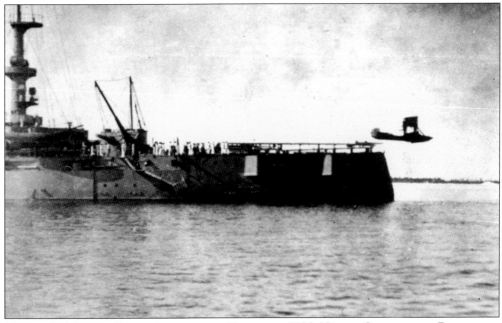

HENRY C. MUSTIN BEING CATAPULTED FROM THE USS NORTH CAROLINA IN PENSACOLA BAY IN 1915. Mustin in a flying boat made the first catapult launch from a moving ship.

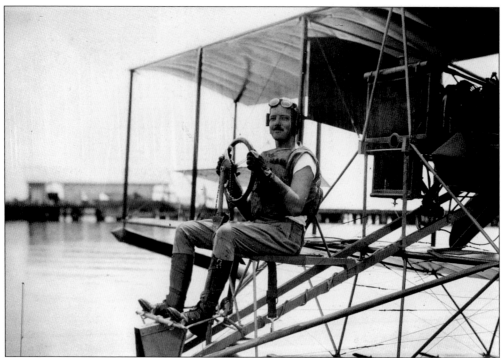

Lt. Comdr. William Merrill Corry (1889–1920) on an AH-9 Trainer in 1915. Corry was Naval Aviator Number 23 and the first Floridian to enter training at Pensacola. He was killed while attempting to rescue a fellow officer from a crashed and burning plane. Corry Station is named for him.

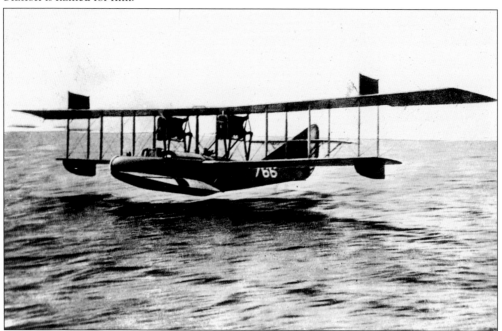

A Curtiss H-12 Flying Boat. A twin engine Curtiss H-12 flying boat #766 comes in for a landing.

CAMP SAUFLEY ON SANTA ROSA ISLAND. Camp Saufley was a temporary seaplane training station. Wall tents were erected on Santa Rosa Island to train pilots in WWI. The camp, as well as Saufley Field, was named in honor of Lt. Richard C. Saufley, a member of NASP's first class and designated Naval Aviator Number 14. In 1916, he set an altitude record of 16,072 feet and an endurance record of 8 hours, 43 minutes of continuous flight. Saufley was killed that same year while attempting to break his own endurance record.

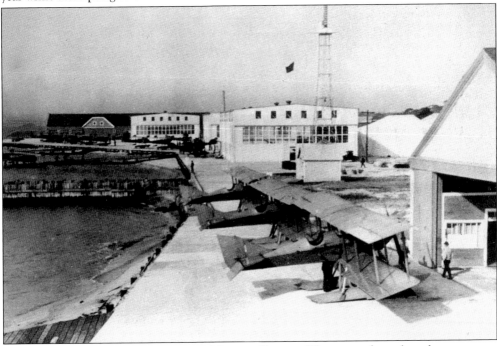

A ROW OF SEAPLANE HANGARS AT MUSTIN BEACH. These metal seaplane hangars were erected between 1916 and 1918.

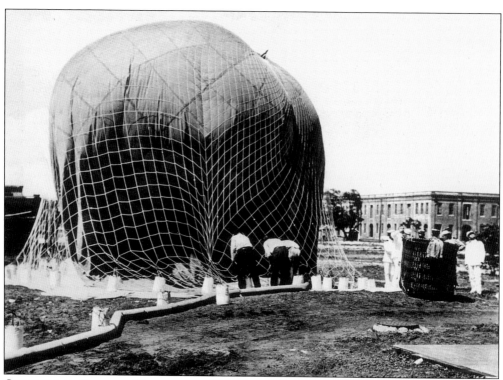

OBSERVATION BALLOON TRAINING AT NASP. A balloon is being prepared for ascent in 1916.

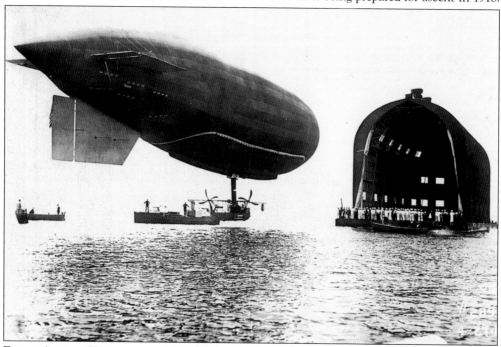

EARLY AIRSHIP TRAINING AT NASP. The DN-1 was the Navy's first airship. The DN-1 made its initial flight on 20 April 1917. Pensacola was one of only two bases devoted to airship training. The airship approaches its floating hangar.

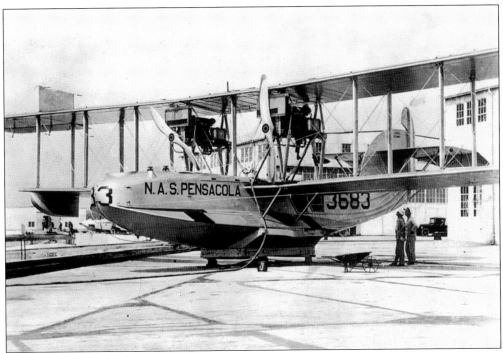

A Curtiss F5L Flying Boat #3683 at the Naval Air Station Pensacola. The F5L became the workhorse of naval aviation after World War I.

A Sailor of the U.S. Navy Aeronautics.

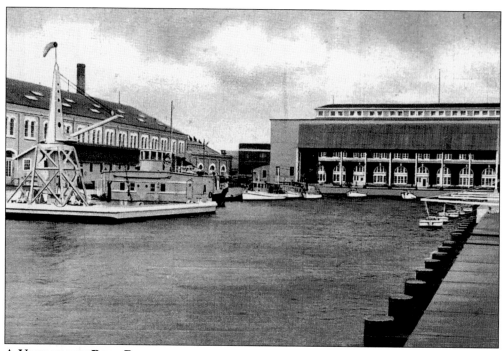

A View of the Boat Basin.

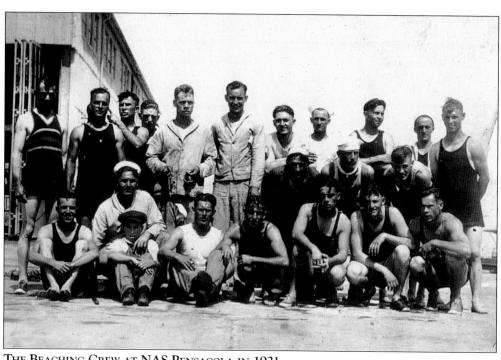

The Beaching Crew at NAS Pensacola in 1921.

A LINE OF WHAT WAS ONCE HANGARS AT CHEVALIER FIELD. Chevalier Field was built on the old Station Field for land-based aircraft. Built in 1917, Station Field had previously been used for balloons and airships. Chevalier Field was the primary landing field for the station until the construction of Sherman Field.

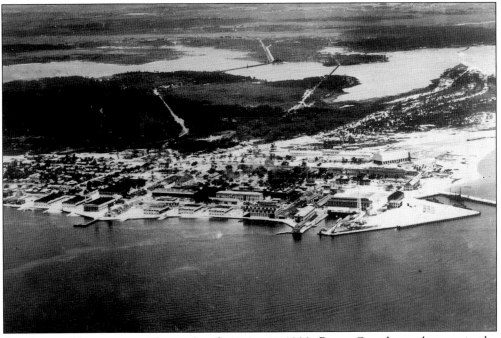

AN AERIAL VIEW OF THE NAVAL AIR STATION IN 1922. Bayou Grande can be seen in the back of the station.

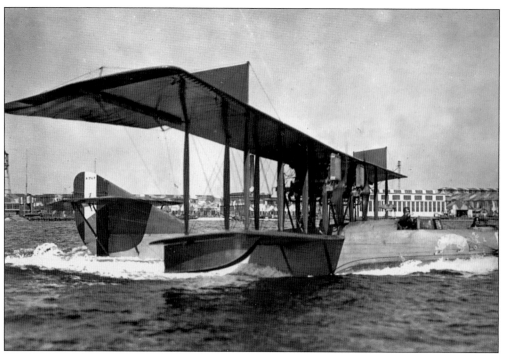

Taxiing Off NASP. The H-12L flying boat taxies off the NAS.

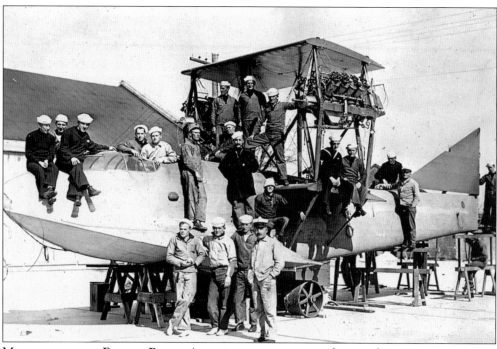

Maintaining a Flying Boat. A maintenance crew works on the twin engine H-12 flying boat.

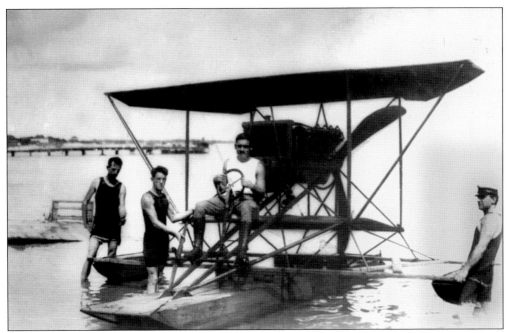

THE FAMOUS "SKIMMER." The Skimmer was used to rescue downed student pilots. It also gave student fliers training in taxiing on the bay.

MEN OF A TRAINING SQUADRON. Sailors and officers of a training squadron pose with a twin-engine aircraft.

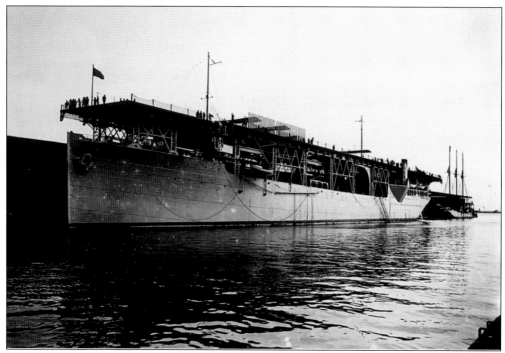

THE USS LANGLEY AT NASP. The USS *Langley* is tied up along side the pier at NAS Pensacola. The *Langley* was the Navy's first carrier. Executive officer of the Langley, Commander Kenneth Whiting was a member of NASP's first class. He was a key figure in the development of early carrier operations and Whiting Field is named for him.

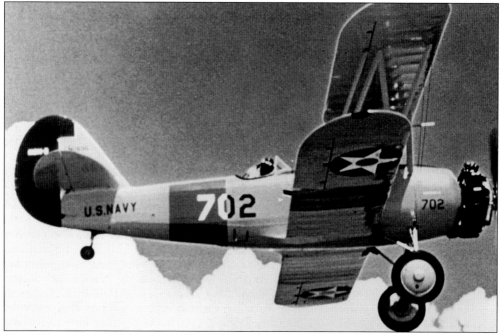

THE "YELLOW PERIL" TRAINER. The all-metal N3N-2 # 702 "Yellow Peril" was used as a primary trainer at NASP.

BRITISH STUDENT PILOTS AT THE NAVAL AIR STATION PENSACOLA. Four thousand British and Commonwealth student pilots were trained at the station during WWII.

THE OLD OCTAGONAL BUILDING. Built in 1834, the octagonal two-story building 16 is the oldest intact building in the original Old Navy Yard. Between 1859 and 1886, it was used as an armory and then a chapel. Because it was a chapel during the Civil War, the retreating Confederates did not burn it in 1862. The building has since been used as a dispensary, Commissioned Officers' Mess, School of Aviation Medicine, and the Navy Relief Society. Building 16 is said to be haunted by the ghost of Marine captain Guy Hall. In 1924, Captain Hall enjoyed playing poker while not on duty as a flight instructor. Captain Hall was killed during a training mission in the 1920s. Since then people in the building have heard what sounds like poker chips hitting the table. The center octagon of the building is the original; the rest was added later.

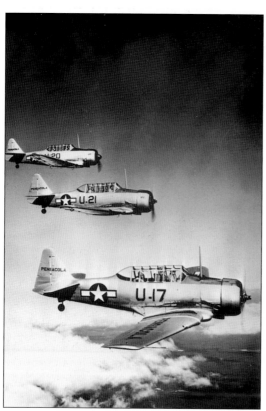

THE SNJ-5 TRAINER. The North American SNJ-5 "Texan" was used as gunnery and instrument trainers. In the 1950s, the SNJ was used for trap landing trainers on carriers that operated in the Gulf.

DEDICATION CEREMONIES AT THE OPENING OF CORRY STATION IN 1934.

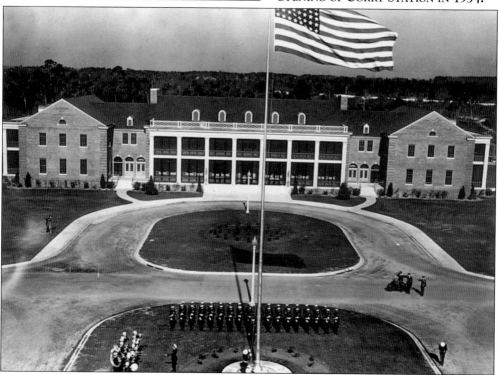

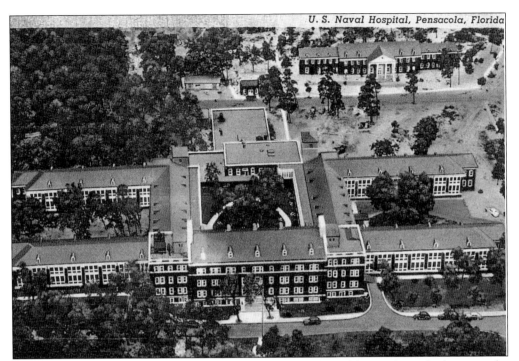

THE SECOND NAVAL HOSPITAL AT NASP. The second naval hospital was built across the street from the old hospital compound. Today, the building is used by the Chief of Naval Education and Training.

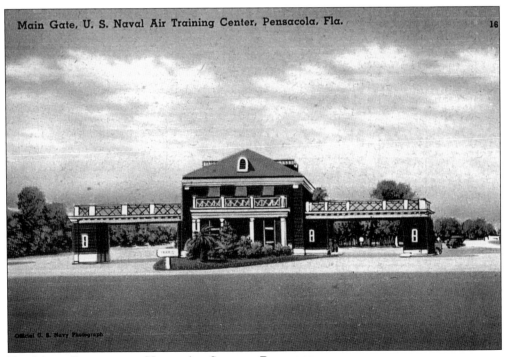

Main Gate, U. S. Naval Air Training Center, Pensacola, Fla. 16

Official U. S. Navy Photograph

THE MAIN GATE AT THE NAVAL AIR STATION PENSACOLA.

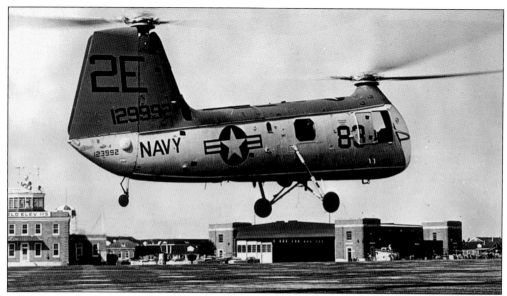

HELICOPTER TRAINING AT ELLYSON FIELD. Used to train helicopter pilots, the HUP Retriever was equipped with a hoist and floor hatch to rescue aviators who ditched at sea. Helicopter training was based out of nearby Ellyson Field from 1950 to1979. Ellyson Field began in 1940 as an auxiliary field for Chevalier Field. Built 16 miles northeast of NASP, it was named for CDR Theodore G. "Spuds" Ellyson, the Navy's first aviator. The field is now an industrial park.

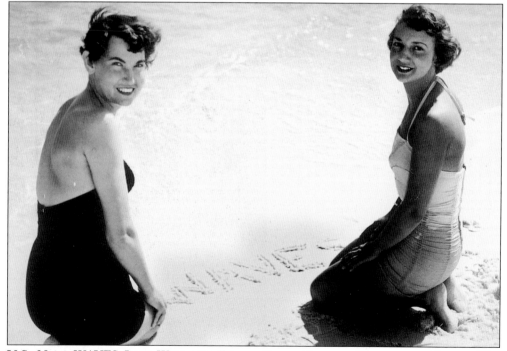

U.S. NAVY WAVES JEAN WISE AND DIANE EISLEY ENJOY A DAY AT THE BEACH. The acronym WAVES stands for Women Accepted for Volunteer Emergency Service and was the Women's Reserve of the U.S. Naval Reserve.

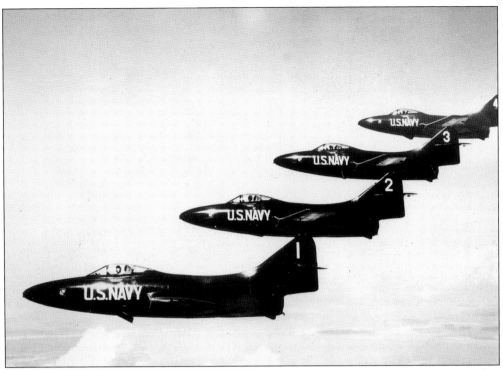

THE BLUE ANGELS IN GRUMMAN F9F-5 PANTHERS. Panthers were used by the Blue Angels between 1949 and 1955 and were the first jets used by the flight demonstration squadron.

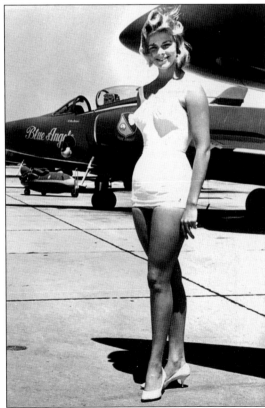

MISS GOLDEN WINGS. Joan Simmons poses in front of F11F Tiger jets of the Blue Angles during the Fiesta of Five Flags celebration. Joan was selected "Miss Golden Wings."

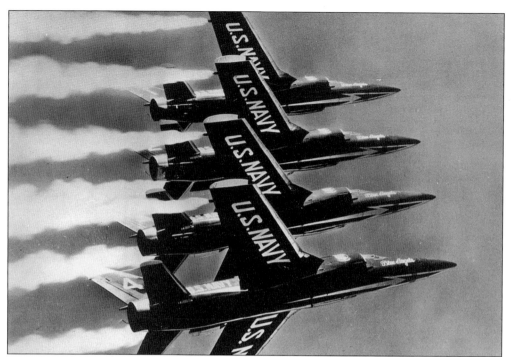

THE F11F TIGERS ARE IN FORMATION. The Tigers were used by the Blue Angels between 1957 and 1968. The plane had the first after-burning engine used by the squadron.

FAT ALBERT AIRLINES. This C-130 Hercules aircraft, affectionately known as "Fat Albert," carries the equipment and personnel needed to perform demonstrations at various air shows. In order to take off from short runways, the crew of "Fat Albert" uses Jet Assisted Take Off (JATO). A 14-second burn of eight solid fuel rockets can propel the aircraft to an altitude of 1,200 feet by adding the power of a fifth engine.

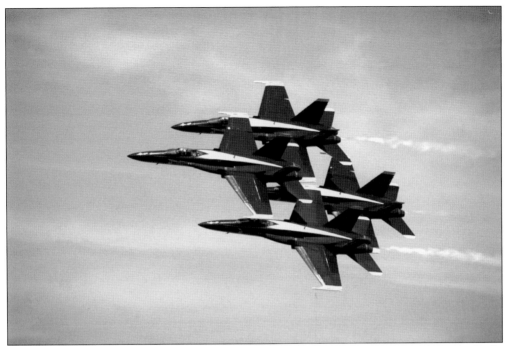

THE FAMOUS DIAMOND FORMATION. The Navy's precision flying team, the Blue Angels, fly the diamond formation. The jets get as close as 36-inches from each other's wing tips. During the training season, the six brightly colored blue and gold F-18 Hornets take off for practice runs from their home base, Sherman Field at Naval Air Station Pensacola.

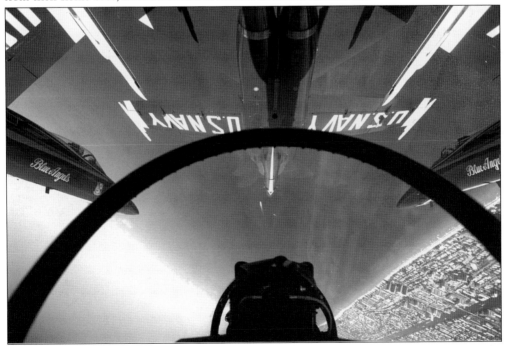

A VIEW OF A FLIGHT FROM THE COCKPIT OF A F-18 HORNET. One can get a sense of the tightness of the Blue Angels' formations.

THE INSIGNIA OF THE BLUE ANGELS FLIGHT DEMONSTRATION SQUADRON. The symbol of the diamond formation in the clouds has made the squadron famous worldwide. The aircraft carrier symbolizes that each pilot has many years as a fleet aviator and is carrier qualified.

ORGANIZATIONS

Two organizations that specialize in military sites are the Council on America's Military Past (CAMP) and the Coast Defense Study Group. Both host an annual conference and publish journals and newsletters. For membership information:

CAMP
518 Why Worry Lane
Phoenix, Arizona 85021
www.campjamp.org

Coast Defense Study Group
634 Silver Dawn Court
Zionsville, Indiana 46077-9088
Attn: Glen Williford
www.cdsg.org

The history-minded people of the Pensacola Bay area have their own historical society. For membership information:

Pensacola Historical Society
110 E. Church Street
Pensacola, Florida 32501
www.pensacolahistory.org